POSTCARD HISTORY SERIES

Seattle

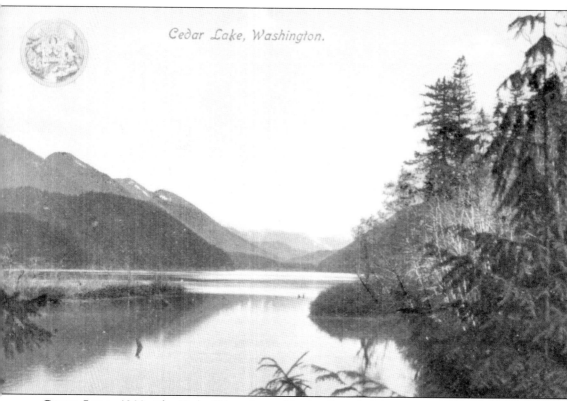

Cedar Lake, Washington.

CEDAR LAKE, 1909. The Cedar River, located in the Cascade Mountains southeast of Seattle, is the source of Seattle's water supply and, beginning in 1905, the location of Seattle's first municipal hydroelectric plant. This image bears the logo of the 1909 Alaska-Yukon-Pacific Exposition. (Courtesy author's collection.)

ON THE FRONT COVER: The luxurious Seattle Hotel, pictured here in 1903, was built in the early 1890s on the site of the former Occidental Hotel after the Great Seattle Fire. Located at the east end of Pioneer Square, it was a favorite stopping place for northward-bound gold-seekers during the Alaska Gold Rush. (Courtesy Kent and Sandy Renshaw.)

ON THE BACK COVER: Colman Dock was originally constructed in 1882 by James Colman, just north of Yesler's Wharf and went through many re-buildings. The new Colman Dock with the imposing clock tower was built in 1908, when this postcard was issued. The dock was a major center for the Mosquito Fleet. Now called Pier 52, it is the Washington State Ferry Terminal. (Courtesy author's collection.)

POSTCARD HISTORY SERIES

Seattle

Mark Sundquist

ARCADIA
PUBLISHING

Published by Arcadia Publishing
Charleston, South Carolina

Printed in the United States of America

Library of Congress Control Number: 2009934874

For all general information contact Arcadia Publishing at:
Telephone 843-853-2070
Fax 843-853-0044
E-mail sales@arcadiapublishing.com
For customer service and orders:
Toll-Free 1-888-313-2665

Visit us on the Internet at www.arcadiapublishing.com

To Rachel, Andrew, and Jackie.
I love you all.

CONTENTS

ACKNOWLEDGMENTS

This project would not have been possible without the assistance of numerous individuals and organizations. I am indebted to all those who helped me. Thank you to author Robin Shannon for encouragement, insight, and technical support. A special thank-you to Dan Kerlee for selflessly sharing his time and images. Thank you Cathy Sundquist for your tireless proofreading. Thank you John Cooper, Kent and Sandy Renshaw, and Ed Weum. Thank you Pacific Northwest Postcard Club (pnpcc.com) and Seattle's Museum of History and Industry. I would also like to thank my editor at Arcadia Publishing, Sarah Higginbotham, for her enthusiasm and constant words of encouragement.

INTRODUCTION

On a chilly rain-soaked November 13, 1851, the Denny Party headed by Arthur Denny landed on the beach at Alki Point in West Seattle. Most of the group had been led by Denny on the difficult journey over the Oregon Trail from Illinois to Portland, Oregon. From Portland, Arthur sent forth his younger brother David and pioneer John Low to scout the Puget Sound country. Low and Denny selected a spot on Alki Point and sent word to the rest of the party to join them. The 12 men and women and 12 children came not as conquerors or as gold-rushers, but as city-builders. Initially they named their settlement New York, then changed the name to *Alki*, which meant "by-and-by" in the local Chinook jargon.

In April 1852, pioneers Arthur Denny, Carson Boren, and William Bell relocated from Alki to the eastern shore of Elliott Bay where downtown Seattle now sits. They had discovered deep water there suitable for the docking of ships, a feature they had been seeking, and which the original landing site lacked. They understood that maritime commerce was essential for their development ambitions. Denny, Boren, and Bell laid out land claims extending along the shoreline from about Denny Way on the north to King Street on the south. They were joined by David "Doc" Maynard, who rowed north from Olympia with Chief Seattle in the chief's canoe. Originally called Duwamps, the settlers renamed the new location Seattle, an Anglicized version of the name of the friendly local Native American chief who had greeted them upon their arrival.

Seattle is fundamentally a maritime city. It was founded on the waterfront, and most of the significant events in the city's history have a maritime connection. Historian Murray Morgan's comment in his best-selling book *Skid Road* is an often-repeated sentiment: "To know Seattle one must know its waterfront." Seattle has also always been a city of visionaries. From the original party of settlers led by Arthur Denny to the Bill Gateses of the modern metropolis, the city was born and nurtured through the imagination and foresight of civic and business leaders who dreamed large.

In October 1852, Henry Yesler arrived in town, seeking the right place to build a sawmill. The earlier settlers, sensing an opportunity to help the city grow, enthusiastically welcomed him and adjusted their land claims to give Yesler a prime waterfront location. The town's first industry was born. Yesler followed up with the construction of a modest dock in 1854, and the little community's fledgling maritime trade took a giant leap forward. Yesler's operation quickly became the commercial and cultural center of the new community. Seattle's first major export was lumber from Yesler's mill. Seattle residents worked in Yesler's mill and on Yesler's Wharf. Yesler's cookhouse became the town's first meeting hall. As the city grew, so did Yesler's activities. He dabbled in grist milling and coal mining. He added extensions to his wharf, until by the 1870s it extended 900 feet into Elliott Bay. Coal had been discovered in the Cascade foothills and became a major export. Yesler added coal bunkers to his wharf. At this time there were several other wharfs along Seattle's waterfront. The area hummed with activity, and by 1880 the town's population had reached 3,500. The growth of Yesler's Wharf mirrored the growth of Seattle and he rebuilt it several times. The era of Yesler's Wharf ended in 1901 when it was replaced by the Pacific Coast Company Pier.

Reginald H. Thompson was another visionary leader who left a huge imprint on Seattle's history. Thompson became city engineer in 1892 and set about implementing the city's plan for a municipal water supply. On June 6, 1889, the Great Seattle Fire had consumed the downtown business district. The private water company's system had failed during the conflagration, and one month later voters approved development of a city-owned water system. After some initial legal issues were resolved, Thompson began laying pipe to tap the abundance of the Cedar River watershed 40 miles southeast of Seattle. Thompson possessed the remarkable foresight to plan a water system that would serve a metropolis of one million people.

Thompson also addressed the issue of electrical power. Fear of the monopolistic, privately held Seattle Electric Company prompted voters to approve a municipal utility, Seattle City Light, in 1902. The plan included a hydroelectric plant on the Cedar River, a feature for which Thompson had lobbied.

Thompson regarded Seattle's notoriously steep hills as an impediment to the natural expansion of the city, and beginning in the late 1890s undertook a massive series of regrades. Throughout the downtown area, huge hills were leveled or lowered, ravines and tidal flats filled in, and hundreds of acres of level ground created. Seattle's Museum of History and Industry calls Seattle "one of the most engineered cities in the world." Thompson also made significant improvements to the city's sewage system, and he totally reorganized the arrangement of the piers on the waterfront.

On July 17, 1897, the steamship *Portland* arrived in Seattle with its legendary "ton of gold" on board, scoured from Canada's Klondike River in the Yukon Territory. The total was actually almost two tons, and the effect on Seattle and the nation was electric. The rush to the Klondike was underway, followed in two years by the Alaska Gold Rush. Seattle merchants "mined the miners" both coming and going. The city embarked on an ambitious advertising campaign selling itself as "the Gateway to Alaska." The Panic of 1893 had hit Seattle hard, but after four long years of grueling economic hardship the city prospered overnight. Merchants, shippers, farmers, coal miners, manufacturers of outfitting equipment, and ship builders enjoyed record sales. Seattle's hotels, restaurants, saloons, and brothels were jammed. The city's population, which had been 42,100 in 1890, mushroomed to 82,000 in 1900, largely on the growth spurt prompted by the Gold Rush.

The Gold Rush was one of the most pivotal events in Seattle's history. It ushered in a prolonged period of skyrocketing population growth and economic prosperity. New streetcar lines branched out in all directions. Suburban homes and communities sprouted like dandelions. Skyscrapers dotted the city skyline. A comprehensive system of parks and boulevards was established, and many other civic improvements were made. In 1909, Seattle celebrated its coming of age as a world-class city by hosting its first world's fair, the Alaska-Yukon-Pacific Exposition (AYPE) on the grounds of the University of Washington. By 1910, the population had exploded to 237,000.

On July 4, 1915, William Boeing and his friend Conrad Westervelt experienced their first airplane rides. Boeing, enthusiastic over the experience and glimpsing the future prospects for aviation, incorporated Pacific Aero-Products on July 15, 1916. On May 9, 1917, Boeing reincorporated as the Boeing Airplane Company. The United States had entered World War I 20 days earlier, and the Boeing Company was receiving a U.S. Navy contract for 50 of its Model C Trainer floatplanes. Thus began a long tradition of cutting-edge innovation in aviation, not only in aircraft design, but socially as well. On May 15, 1930, Boeing Air Transport placed Ellen Church, the world's first stewardess, in a Model 80A on the Oakland to Chicago route.

The forward-looking nature of Seattle was reaffirmed when it hosted its second world's fair, the technologically-oriented, space-age themed Century 21 Exposition in 1962.

One

SEATTLE'S
NATIVE AMERICAN
HERITAGE

Any history of Seattle would be incomplete without acknowledging the important role that local Native Americans played in the city's history. Their contribution went far beyond the use of a local Native American chief's name for the city. When Seattle's original settlers, the Denny Party, landed on Alki Point in West Seattle on November 13, 1851, they were greeted by a group of Native Americans led by Chief Seattle himself. The natives were friendly and hospitable, and assisted the settlers in getting established. In early 1852, when the pioneers relocated across Elliott Bay, where the beachfront was better suited for a deepwater port, helpful natives again assisted. When Seattle pioneer Doc Maynard moved from Olympia to Seattle in early 1852, it was his friend Chief Seattle who paddled him up Puget Sound in his own canoe. Native laborers helped build Doc Maynard's store and operate Henry Yesler's saw mill. When the brief Indian War of 1856 broke out, the Puget Sound natives under Chief Seattle's control resolved to remain on peaceful terms with the settlers, and some historians claim that it was neighborly Native Americans who warned the village's residents of the impending danger.

After the Alaska Gold Rush began in 1897, all things Alaskan became the rage in Seattle, including Native American artifacts of Alaska and the northwest coast of British Columbia. The native art of the Far North became closely intermingled with that of Puget Sound. Perhaps nowhere is the region's Native American heritage more pronounced than in the many geographic names of Puget Sound Indian origin. The Native American word *mish* means "people," and so the region has the Duwamish River, the Snohomish River, the town of Skykomish, the Stillaguamish River, Lake Sammamish, and so on. Kitsap County, the county directly across Puget Sound from Seattle, is named for Chief Kitsap, leader of the Suquamish tribe in the early 1800s. Other local names of Native American origin include Puyallup, Issaquah, Mukilteo, Tacoma, Snoqualmie, Chehalis, and Nisqually, to name a few. The permanence of geographic names provides assurance that the region's Native American legacy will never be lost completely.

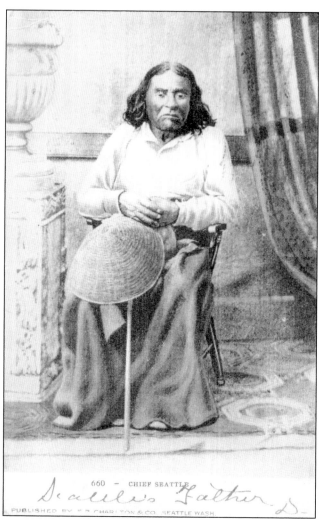

CHIEF SEATTLE. This is the only known photograph of Chief Seattle. It was taken around 1865 by E. M. Sammis, Seattle's first photographer. Chief Seattle died in 1866. The image has often been touched up to make his eyes appear open, though his eyes are closed in the original photograph. Some reproductions include designs added to Chief Seattle's clothing and hat, and colorized reproductions show the chief wearing a wide variety of clothing colors. Some reproductions also place him in a variety of backgrounds. (Courtesy author's collection.)

660 - CHIEF SEATTLE

PUBLISHED BY E. D. CHARLTON & CO. SEATTLE WASH.

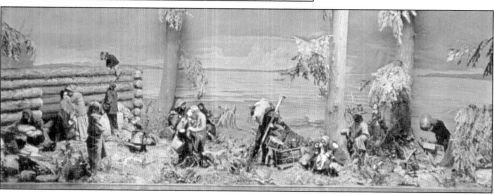

DENNY PARTY LANDING. This diorama of the Denny Party landing at Alki in West Seattle on November 13, 1851, is on display at Seattle's Museum of History and Industry. It was carefully constructed from pioneer accounts. A group of welcoming Native Americans led by Chief Seattle himself greets the new arrivals. Chief Seattle is in the left center foreground. (Courtesy author's collection.)

PRINCESS ANGELINE. Kikisoblu, or Princess Angeline, as she was nicknamed by early Seattle residents, was Chief Seattle's daughter. She was a beloved figure among early Seattle residents and close friends with Seattle's pioneers. When postcards became popular around the turn of the century, images of Princess Angeline were as popular as those of Chief Seattle. Angeline died on May 31, 1896. (Courtesy author's collection.)

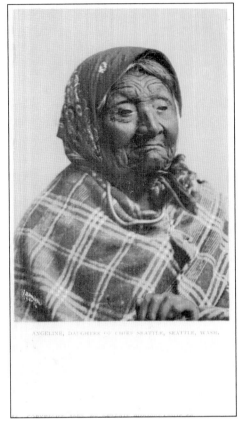

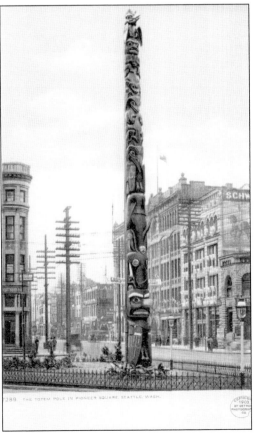

PIONEER SQUARE TOTEM POLE, 1903. In 1899, a Tlingit totem pole was removed under suspicious circumstances from a Tlingit village on Tongass Island, Alaska, by a Seattle Chamber of Commerce expedition and installed in Seattle's Pioneer Square. Despite the questionable conditions surrounding the totem pole's acquisition, it immediately became a source of civic pride, a symbol of Seattle, and a reflection of Alaskan influence in Seattle during the Gold Rush. (Courtesy author's collection.)

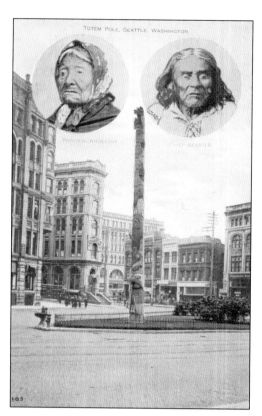

PIONEER SQUARE TOTEM POLE, C. 1909. This image has Chief Seattle and Princess Angeline superimposed next to the Tlingit totem pole in Pioneer Square. Images like this created an association in the public's mind between Puget Sound Indians, Seattle, and totem poles. However, Puget Sound Indians did not traditionally carve totem poles. The Pioneer Square totem pole was Seattle's first. (Courtesy author's collection.)

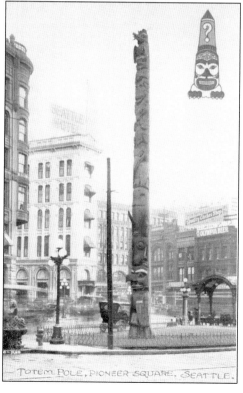

PIONEER SQUARE TOTEM POLE, 1912. This Golden Potlatch postcard reflects three separate Native American influences. The logo of the Golden Potlatch community celebration is in the upper right corner, the Pioneer Square totem pole is in the center, and the bronze drinking fountain topped with the bust of Chief Seattle is in the lower left corner. The drinking fountain and bust were cast by famed Seattle sculptor James Wehn. (Courtesy author's collection.)

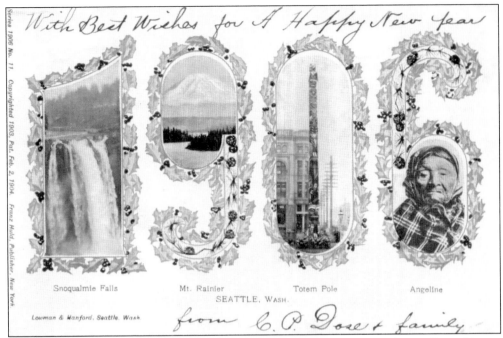

With Best Wishes for A Happy New Year

Snoqualmie Falls Mt. Rainier Totem Pole Angeline
SEATTLE, WASH.

Lowman & Hanford, Seattle, Wash. from C. P. Dose + family.

CHRISTMAS GREETING POSTCARD, 1906. The holly surrounding the numbers indicate this was a holiday greeting card from Seattle. Included in the Seattle area scenes are the Pioneer Square totem pole and Princess Angeline. (Courtesy author's collection.)

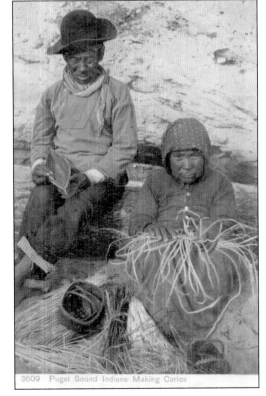

3609 Puget Sound Indians Making Curios

PUGET SOUND INDIANS MAKING CURIOS, 1904. Making curios and artifacts to sell to tourists was a common way for Native Americans to earn a living in early Seattle. Many of these objects were not cheap souvenirs but finely crafted authentic Native American artifacts that found their way into museums across the country. Joseph Standley, owner of Ye Olde Curiosity Shop, was a major broker for these objects. (Courtesy author's collection.)

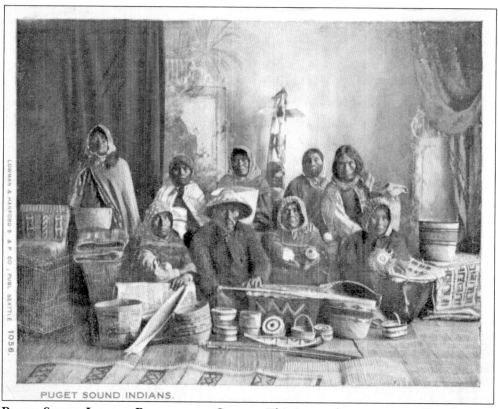

PUGET SOUND INDIANS.

PUGET SOUND INDIANS POSING WITH CURIOS. This image shows a group of local Native Americans posing with their products for sale around 1906. Among the objects are a large number of well-made, colorful baskets, blankets, model canoes, and a totem pole. (Courtesy author's collection.)

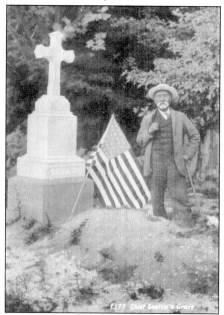

CHIEF SEATTLE'S GRAVE, 1910. At Chief Seattle's funeral in 1866, one of his sons produced a copy of the now famous photograph of the chief and said, "The white man will not forget him, for here is his picture, made by the lights of the heavens, the older it grows the more it will be prized. When the Seattles are no more, their chief will be remembered and revered by generations to come." (Courtesy author's collection.)

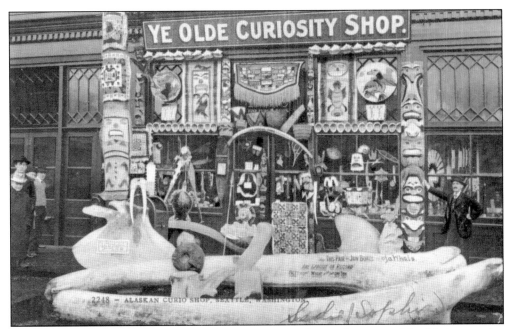

YE OLDE CURIOSITY SHOP, 1910. At least six totem poles can be counted in this image, plus numerous other Native American artifacts. Located on Seattle's bustling waterfront, the shop was instrumental in popularizing totem poles and Alaskan native art in Seattle. Note that the shop is identified as an "Alaskan Curio Shop." (Courtesy author's collection.)

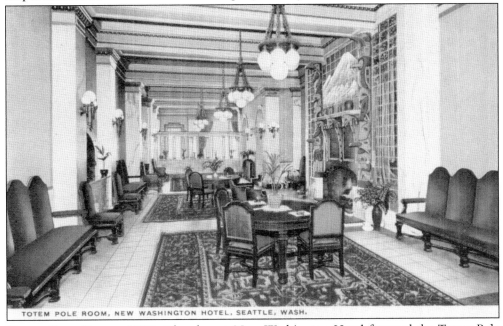

TOTEM POLE ROOM, 1908. The elegant New Washington Hotel featured the Totem Pole Room, which had a massive fireplace with a mural of Mount Rainier flanked by two totem poles. The totem pole on the left was patterned after the Pioneer Square totem pole. The totem pole on the right was patterned after the famous Chief Shakes totem pole in Wrangell, Alaska. (Courtesy author's collection.)

15

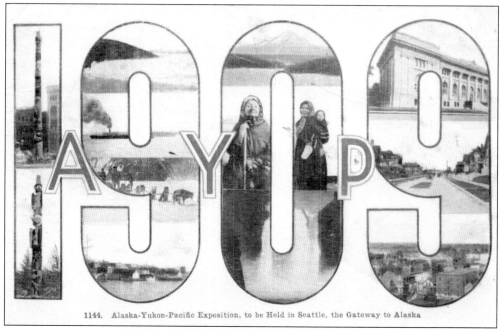

1144. Alaska-Yukon-Pacific Exposition, to be Held in Seattle, the Gateway to Alaska

ALASKA-YUKON-PACIFIC EXPOSITION, 1909. This postcard features Alaska- and Seattle-related images within the numbers. Included are several Native American scenes. The familiar Pioneer Square totem pole is at the top of the number one, and Princess Angeline is in the zero. (Courtesy author's collection.)

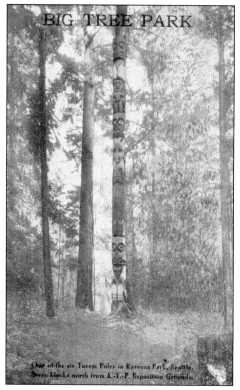

RAVENNA PARK TOTEM POLE, 1909. A visit to Ravenna Park was considered an integral part of a visit to the Alaska-Yukon-Pacific Exposition. The text on the card reads, "Big Tree Park. One of the six Totem Poles in Ravenna Park, Seattle. Seven blocks north from the A-Y-P Exposition grounds." Ye Olde Curiosity Shop's Joseph Standley was responsible for placing the totem poles in the park. (Courtesy author's collection.)

PRINCESS ANGELINE'S COTTAGE, 1910. The text on the card reads, "Princess Angeline (Daughter of Chief Seattle) at her Cottage Foot of Pike Street, Seattle, Washington." Note Angeline's dog standing on its hind legs next to her. (Courtesy author's collection.)

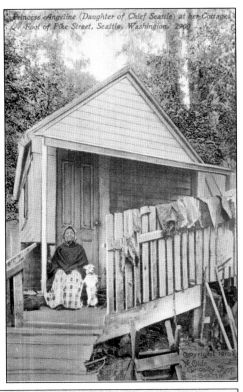

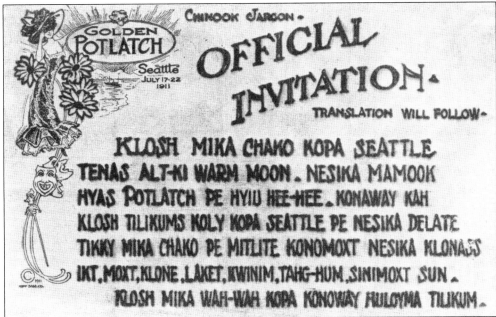

SEATTLE'S FORGOTTEN LANGUAGE. This 1911 Golden Potlatch invitation is written in Chinook jargon, a hybrid trade language that developed out of the need for various Native American groups and European Americans to communicate with each other. Chinook words persisted in the vocabulary of many Seattle residents well into the 20th century. The Golden Potlatch was Seattle's original community festival.(Courtesy author's collection.)

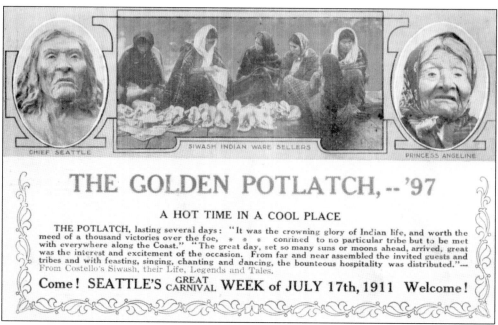

CHIEF SEATTLE SIWASH INDIAN WARE SELLERS PRINCESS ANGELINE

THE GOLDEN POTLATCH, -- '97

A HOT TIME IN A COOL PLACE

THE POTLATCH, lasting several days: "It was the crowning glory of Indian life, and worth the meed of a thousand victories over the foe, * * * confined to no particular tribe but to be met with everywhere along the Coast." "The great day, set so many suns or moons ahead, arrived, great was the interest and excitement of the occasion. From far and near assembled the invited guests and tribes and with feasting, singing, chanting and dancing, the bounteous hospitality was distributed."— From Costello's Siwash, their Life, Legends and Tales.

Come! SEATTLE'S GREAT CARNIVAL WEEK of JULY 17th, 1911 Welcome!

GOLDEN POTLATCH, 1911. Seattle's first Golden Potlatch celebration was held in 1911. "Golden" was a reference to all the benefits bestowed on the city by the Alaska Gold Rush. "Potlatch" was borrowed from the practice of gift giving ceremonies held by Pacific Northwest Coast Indians. Note the moccasins being sold by the Native American street sellers in the center. (Courtesy author's collection.)

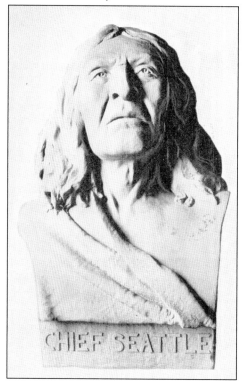

CHIEF SEATTLE BUST, 1918. Between about 1909 and 1912, Seattle sculptor James Wehn cast several busts of Chief Seattle in addition to the statue of Chief Seattle at Tilikum Place. Wehn carefully studied the photograph of Chief Seattle before beginning his sculptures. Wehn's art was a popular subject for postcards in early Seattle, and his sculptures are still on display around Seattle today. (Courtesy author's collection.)

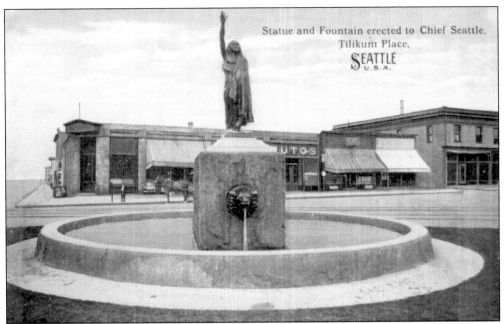

TILIKUM PLACE, 1915. This statue of Chief Seattle and the small park around it are located at Fifth and Denny, Seattle. Facing toward West Seattle, the Chief's right arm is raised in a symbolic gesture of greeting to the original settlers. *Tilikum* is a Chinook word meaning "greeting" or "welcome." The park was dedicated on Founders Day, November 13, 1912. Chief Seattle's great-great-granddaughter Myrtle Loughery unveiled the statue. (Courtesy author's collection.)

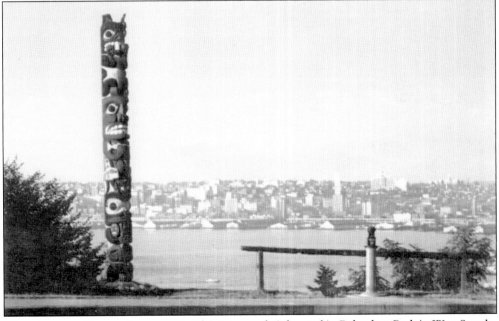

WEST SEATTLE TOTEM POLE, 1939. This totem pole is located in Belvedere Park in West Seattle. The location has a spectacular view across Elliott Bay to downtown Seattle. The pole was a gift to the city from J. E. Standley, owner of Ye Olde Curiosity Shop. (Courtesy author's collection.)

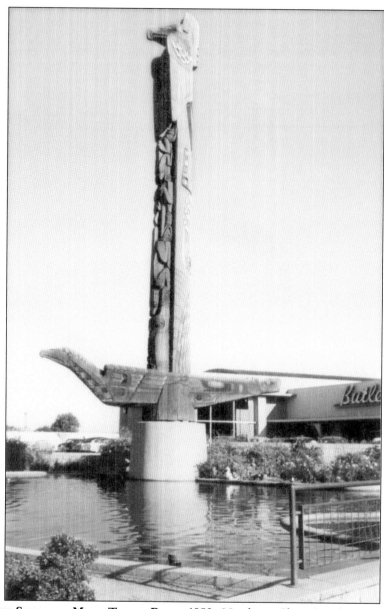

Northgate Shopping Mall Totem Pole, 1952. Northgate Shopping Center was the first shopping mall in the Pacific Northwest and one of the first in the nation. Conceived by Rex Allison, president of the Bon Marche, it opened on April 21, 1950, although it was not fully occupied until 1952. In keeping with Seattle's heritage, a large totem pole was placed at its entrance in 1952. The pole was carved by famed Redmond sculptor Dudley Carter. Although white, Carter had spent time among the Tlingit and Kwakwaka'wakw Indians during his childhood in British Columbia, and assimilated native influences that were reflected in his art. The Northgate totem pole was an original and nontraditional design by Carter with Pacific Northwest, Native American, and possibly other cultural influences. Carter has numerous sculptures in the Greater Seattle area. His former Redmond home is now a historical site. The Northgate totem pole was removed for renovation in 2006 and donated to the Suquamish tribe, who refurbished it and erected it in front of the Clearwater Casino Resort in 2008. (Courtesy author's collection.)

Two

EARLY YEARS

Seattle grew slowly at first. The original 1851 Denny Party of 24 men, women, and children grew to 150 people in 1860 and then 350 people by 1865. Henry Yesler's mill was the town's center of activity. In 1854, Yesler added a wharf to accommodate the rapidly growing export of lumber. The town's commercial district ran four blocks from Mill Street, now Yesler Way, south to King Street along First Avenue South. The original town site was a six-acre spit of land that jutted south from the mainland. To the south lay tidal flats, and to the east was a saltwater marsh. It was, in many ways, a typical Western frontier town. All buildings were made of wood, and the town had a hastily built, somewhat haphazard appearance. The filling in of the tidal flats adjacent to the waterfront began almost immediately with the dumping of sawdust from Yesler's mill and ballast from visiting ships. Land was slowly reclaimed from the sea.

During the 1870s, the discovery of coal in Renton and Newcastle gave Seattle a new export, second only to lumber. So great was demand for the region's coal that it could be called Seattle's black gold. The Seattle and Walla Walla Railroad was built to carry coal from the bustling mines to a new wharf on the waterfront. For a time, Newcastle almost equaled Seattle in size. Much of Seattle's lumber and coal was bound for San Francisco, which was booming after the California Gold Rush. So much ballast from San Francisco was dumped in Elliott Bay by ships coming to load cargo, that the area between Pioneer Square and the current waterfront is said to be made largely from Nob Hill, San Francisco. Seattle, already growing rapidly by the 1880s, was affected significantly by the arrival of the Northern Pacific Railroad in Tacoma in 1887. For the first time, Puget Sound had a transcontinental railroad connection. Puget Sound hummed with a fleet of steamers, called the Mosquito Fleet, visiting all the communities around the Sound. The city tripled in size to around 42,000 during the decade.

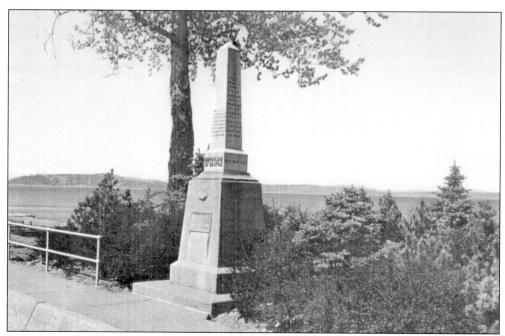

SEATTLE BIRTHPLACE MONUMENT. This monument on Alki Beach in West Seattle, with beautiful, sweeping views up and down Puget Sound, marks the spot where the Denny Party, Seattle's original settlers, first landed. The inscription on the monument reads, "At this place on 13 November 1851, there landed from the Schooner Exact Captain Folger the little colony which developed into the City of Seattle." (Courtesy author's collection.)

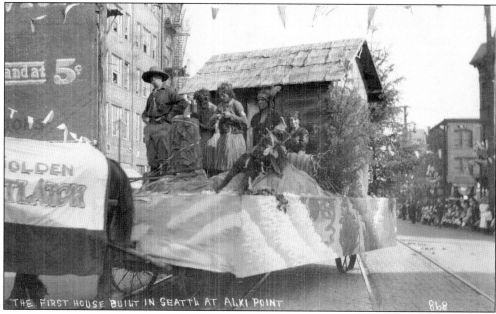

DENNY CABIN, 1851. This horse-drawn float in the 1911 Golden Potlatch parade featured a re-creation of the first house the Denny Party built on Alki Beach in 1851, complete with pioneers and Native Americans. (Courtesy Dan Kerlee.)

22

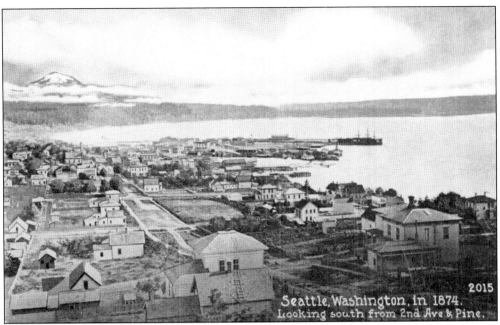

SEATTLE IN 1874. The view is looking south over the city from the southern slope of Denny Hill (now removed). Several wharfs line the waterfront. Yesler's Wharf with its complex of buildings is visible in right center. The town's population is around 1,500. (Courtesy Dan Kerlee.)

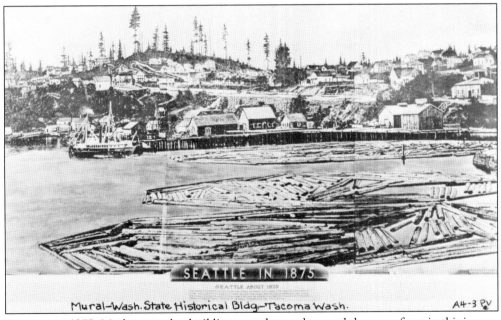

SEATTLE IN 1875. Modest wooden buildings are clustered around the waterfront in this image, at a time when logging is Seattle's main industry. The tidal flats below the bluff adjacent to Front Street have not yet been filled in. Denny Hill, removed by later regrading, rises sharply in left center. All of the once-thick forest has been removed in the vicinity of the village. (Courtesy author's collection.)

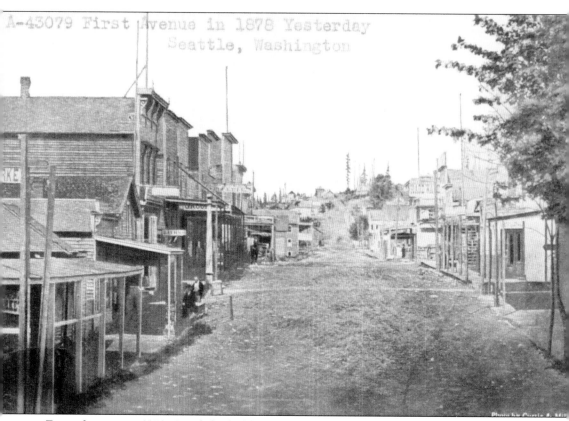

A-43079 First Avenue in 1878 Yesterday
Seattle, Washington

FIRST AVENUE IN 1878. Seattle looks like a typical Western frontier town in this scene looking north up Front Street (First Avenue) toward Denny Hill. All buildings in view are simple one- to three-story wooden structures with wooden sidewalks in front. Most have almost certainly been built with lumber from Yesler's Mill. (Courtesy John Cooper.)

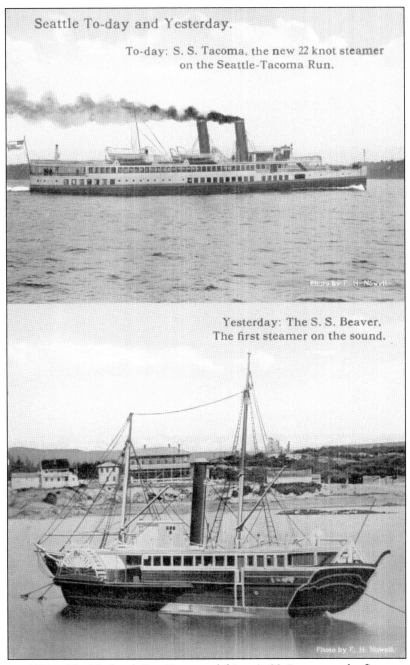

Seattle To-day and Yesterday.

To-day: S. S. Tacoma, the new 22 knot steamer
on the Seattle-Tacoma Run.

Photo by F. H. Nowell

Yesterday: The S. S. Beaver,
The first steamer on the sound.

Photo by F. H. Nowell

SS BEAVER, 1870s. The Hudson's Bay Company's historic SS *Beaver* was the first steamship on the west coast of North America. It was also the first steamship on Puget Sound in 1841. Built in England in 1835, the *Beaver* sailed around the tip of South America and up to Fort Vancouver (now Vancouver, Washington), where its steam engine was assembled and its paddlewheels mounted. Its engines were built to burn either wood or coal. It could burn up to 40 cords of wood in half a day, or as much as one ton of coal an hour. It had a long career, first as a fur trading vessel, then as a survey ship, and a passenger and cargo vessel. It ran aground at Stanley Park in Vancouver, Canada, and broke up in 1888. (Courtesy Dan Kerlee.)

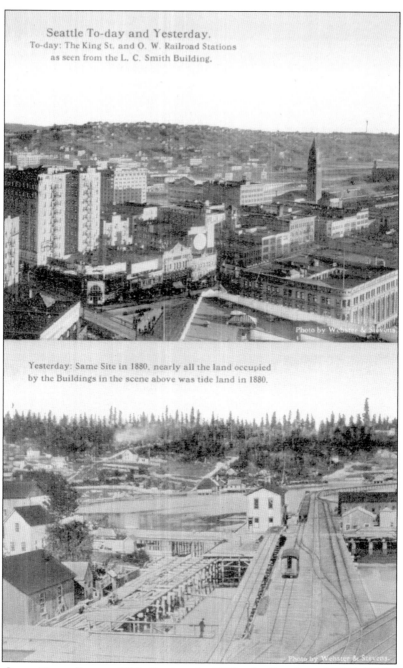

Seattle To-day and Yesterday.
To-day: The King St. and O. W. Railroad Stations
as seen from the L. C. Smith Building.

Photo by Webster & Stevens.

Yesterday: Same Site in 1880, nearly all the land occupied
by the Buildings in the scene above was tide land in 1880.

Photo by Webster & Stevens.

TRESTLE OVER TIDAL FLATS, 1880. During the 1870s, the Seattle and Walla Walla Railroad built a long trestle over the tidal flats just south of Seattle to the huge new King Street Coal Dock. The booming coal mines at Newcastle now had direct access to the Seattle waterfront. For a time in the 1870s and 1880s, Newcastle, tucked away in the Cascade Mountain foothills southeast of Seattle, almost rivaled Seattle in size. By the 1880s, Newcastle was shipping over one million tons of coal annually, almost all of it passing through the Seattle waterfront, providing Seattle with a valuable new industry. Newcastle faded away in the early 20th century as oil replaced coal as an energy source. (Courtesy author's collection.)

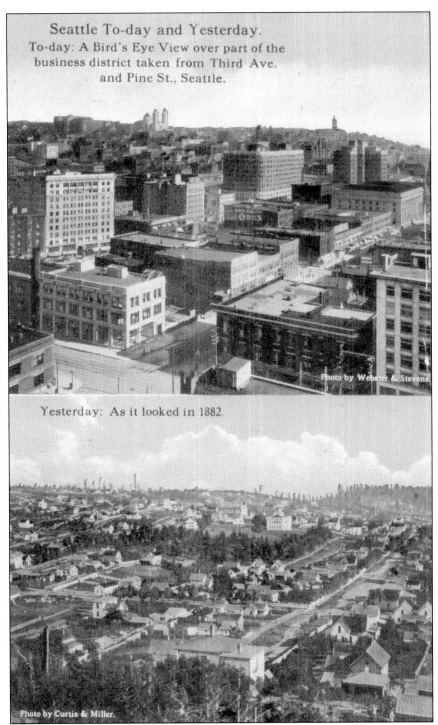

Seattle To-day and Yesterday.
To-day: A Bird's Eye View over part of the business district taken from Third Ave. and Pine St., Seattle.

Photo by Webster & Stevens.

Yesterday: As it looked in 1882.

Photo by Curtis & Miller.

FIRST HILL, 1882. The lower 1882 image looks southeast toward First Hill, just east of downtown, from the southern slope of Denny Hill at Third Avenue and Pine Street. Considerable growth has taken place since the mid-1870s. The upper image shows the same scene in 1914. (Courtesy author's collection.)

27

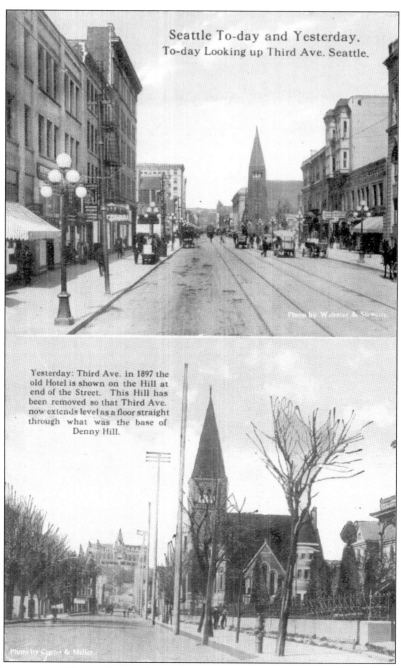

Seattle To-day and Yesterday.
To-day Looking up Third Ave. Seattle.

Yesterday: Third Ave. in 1897 the old Hotel is shown on the Hill at end of the Street. This Hill has been removed so that Third Ave. now extends level as a floor straight through what was the base of Denny Hill.

THIRD AVENUE AND DENNY HILL. These images compare the view up Third Avenue before and after the regrading. The abrupt rise of steep Denny Hill blocked the northern extension of Second, Third, Fourth, and Fifth Avenues. The lower view looks north up Third Avenue to the steeply rising Denny Hill. In addition to the removal of Denny Hill, the Third Avenue regrade through downtown involved 95 acres, 2.6 miles of street, and the removal of 5.4 million cubic yards of dirt. Property owners, especially retailers in the affected areas, had petitioned the city for regrades and street widening. The upper post-regrading *c.* 1914 view shows Third Avenue "level as a floor straight through what was the base of Denny Hill." (Courtesy author's collection.)

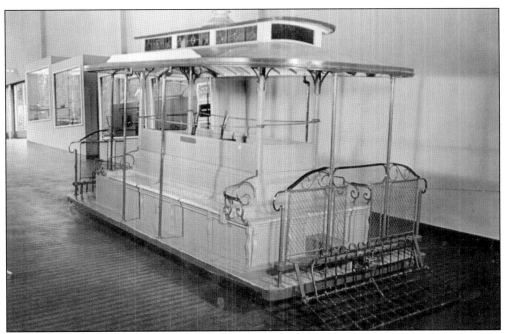

CABLE CAR NO. 13. The caption on the reverse reads, "Pride of the Yesler Way Route in 1888, clanged up and down the steep hills of Seattle. This city was the first in the nation to use an electrified street railway." The route ran from Pioneer Square to Leschi Park on Lake Washington. (Courtesy author's collection.)

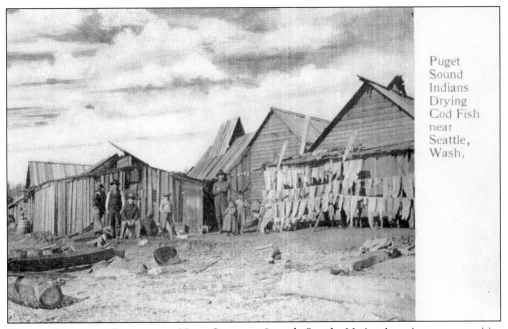

Puget Sound Indians Drying Cod Fish near Seattle, Wash.

NATIVE AMERICAN COMMUNITY NEAR SEATTLE. In early Seattle, Native American communities and the new town coexisted peacefully near each other. In this image the residents are living in traditional houses made of split cedar boards and using traditional dugout cedar canoes, but have adopted the style of dress of white settlers, whom they called "Bostons." (Courtesy Dan Kerlee.)

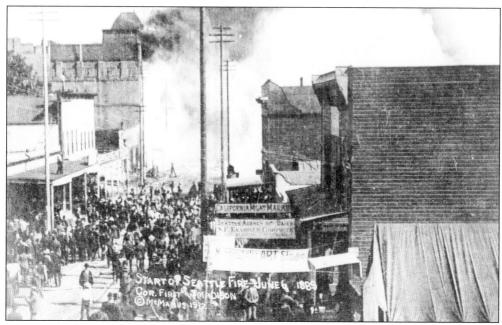

START OF SEATTLE FIRE, JUNE 6, 1889. The fire started in the basement of a cabinet shop at the corner of First Avenue and Madison Streets four blocks north of what is now Pioneer Square. This view looks south down First Avenue from Spring Street. Frye's Opera House burns in left center. (Courtesy John Cooper.)

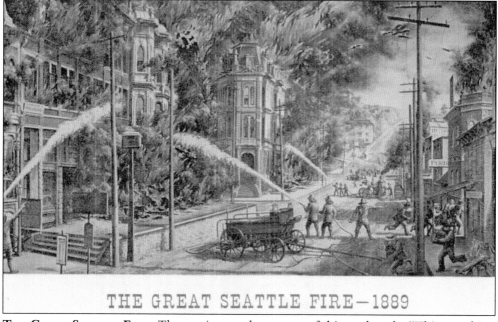

THE GREAT SEATTLE FIRE. The caption on the reverse of this card reads, "This mural is a historically accurate portrayal of a scene in Yesler Way on June 6, 1889. Fire, which started at two-thirty in the afternoon, burned until three o'clock the following morning. Seattle's entire business district, consisting of sixty-four acres of buildings, was burned out. The picture was painted by Mr. Rudolph Zallinger." (Courtesy Museum of History and Industry.)

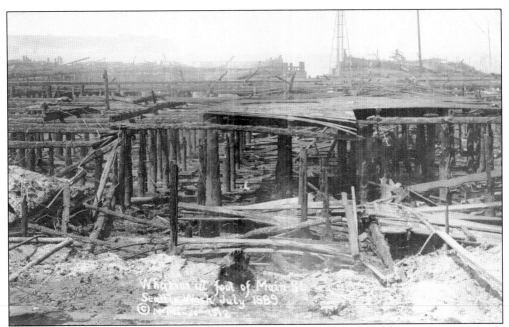

GREAT SEATTLE FIRE AFTERMATH. This rare view shows the hopelessly charred wharfs at the foot of Main Street. The view is west across Elliott Bay. West Seattle is visible in the distance. The photograph was taken two blocks south of Pioneer Square. Most of the waterfront except for four wharfs was consumed by the inferno. (Courtesy John Cooper.)

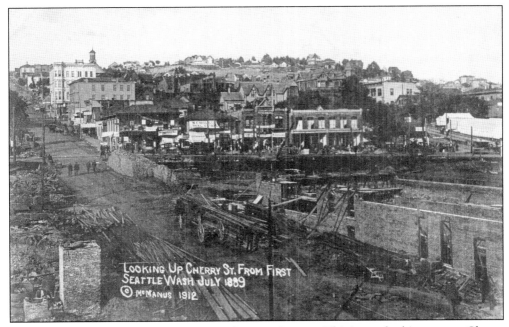

GREAT SEATTLE FIRE AFTERMATH FROM CHERRY STREET. This image looking east up Cherry Street toward First Hill shows the limits of the fire. Many commercial buildings and residences adjacent to the fire zone are intact, and most buildings east of Fourth Avenue survived. (Courtesy John Cooper.)

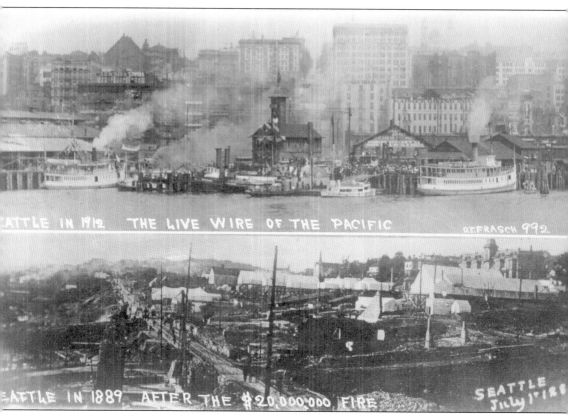

GREAT SEATTLE FIRE AFTERMATH. The lower image shows Seattle's commercial district on July 1, 1889, some three weeks after the fire. Front Street, now First Avenue, heads north. Tents have sprouted and business has resumed. A few unscathed buildings are visible on First Hill in far upper right. Visible on the left in the lower image is how First Avenue was built on the edge of a bluff, which sloped sharply downhill directly to the water's edge. Buildings here had been built elevated so that the fronts were level with the street. Later regrading and filling in of the shoreline pushed the waterfront two blocks westward. (Courtesy Dan Kerlee.)

Three

THE MAKING OF A WORLD-CLASS CITY

The 20-year period from 1889 to 1909 radically altered Seattle from a rough frontier town to a bustling cosmopolitan city. The town had been hastily built of wood, and on June 6, 1889, an overturned pot of glue started a fire that raged through the entire downtown, reducing everything including the docks to smoldering ruins. The disaster was a blessing in disguise. Out of the ashes arose the foundation of a modern metropolis. A new building code mandated the use of brick and stone. Later, the visionary city engineer R. H. Thompson began radically regrading the city. This leveling process created large areas for the expansion of the downtown business district and greatly improved transportation by making the streets easier to use.

In 1893, James Hill's Great Northern Railroad reached the city, linking Seattle directly to the rest of the country via transcontinental railroad. This had been the dream of the city's fathers ever since the city was founded.

Seattle was struggling economically after the Panic of 1893, but on July 17, 1897, salvation arrived. The steamship *Portland* docked in Seattle with almost two tons of gold on board from the Klondike River in Canada's Yukon Territory. This triggered the Alaska Gold Rush to the Klondike, and then Nome. (Most prospectors passed through Skagway, Alaska on their way to the Klondike.) Seattle's publicity program promoting itself as the "Gateway to Alaska" attracted national and international attention. Thousands of prospectors poured through the city both going and returning. The Royal Canadian Mounted Police required a literal ton of supplies to survive the harsh conditions of the Far North, and Seattle merchants became wealthy by outfitting gold stampeders. Seattle, with its booming economy, attracted more people than the Gold Rush attracted prospectors.

Between 1899 and 1914, the regrades of Denny, Jackson, and other streets transformed the city. Hundreds of acres of tidal flats were filled in and business quickly followed, taking advantage of the newly created land. A lively business in tidal flats land speculation developed. New rail lines stretched across the fresh terrain and along the waterfront to help shuttle Seattle's huge quantities of trade goods to destinations near and far.

Seattle proclaimed its good fortune and its close ties with the Far North and the Pacific Rim when it hosted the Alaska-Yukon-Pacific Exhibition on the grounds of the University of Washington in 1909.

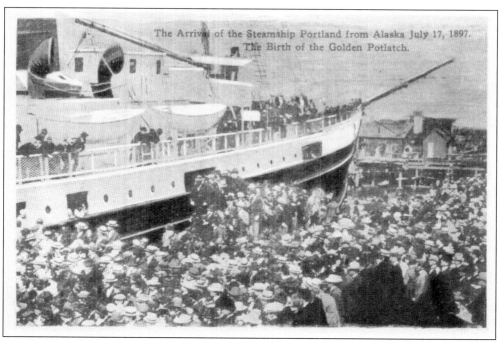

ARRIVAL OF THE STEAMSHIP *PORTLAND*, JULY 17, 1897. Jubilant crowds gather around the steamship *Portland* during its arrival in Seattle from Alaska with its legendary "ton of gold" on board. Imaginative Seattle entrepreneurs offered everything from snow bicycles to arctic underwear to eager prospectors. (Courtesy author's collection.)

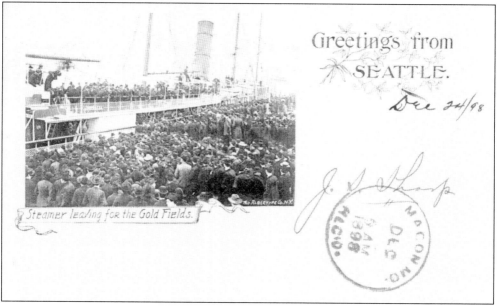

STEAMER LEAVING FOR THE GOLD FIELDS. This Albertype souvenir card postmarked 1898 shows the steamer *Australia* boarding. Both the ship and the wharf are jammed, a scene that was typical during the gold fever that gripped Seattle during the Klondike Gold Rush. (Courtesy Dan Kerlee.)

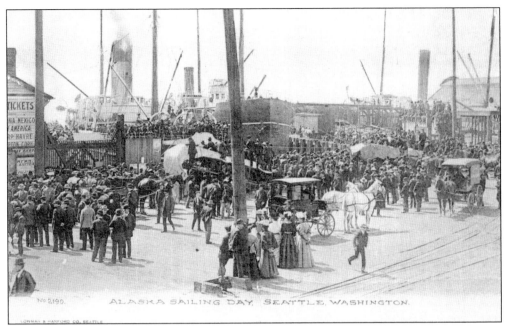

ALASKA SAILING DAY, C. 1898. This is another typical waterfront scene during the excitement of the Klondike and Alaska Gold Rushes. The wharf and ship are packed. Many dangerously overloaded ships left for the Far North, and worn-out, barely seaworthy ships were resurrected and placed on the Alaska run. (Courtesy Dan Kerlee.)

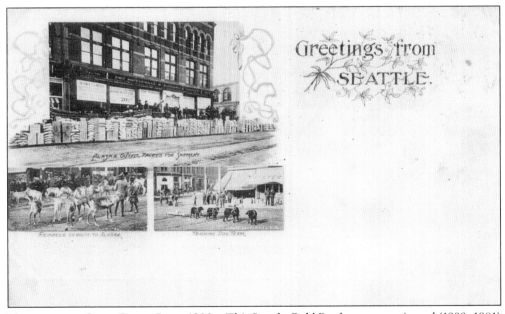

VIEWS OF THE GOLD RUSH, LATE 1800s. This Seattle Gold Rush era souvenir card (1898–1901) shows Gold Rush scenes. At the top, outfitting equipment is stacked in front of the MacDougall and Southwick Company store. At the bottom left is a group of reindeer. At bottom right is a dogsled team in training. (Courtesy Dan Kerlee.)

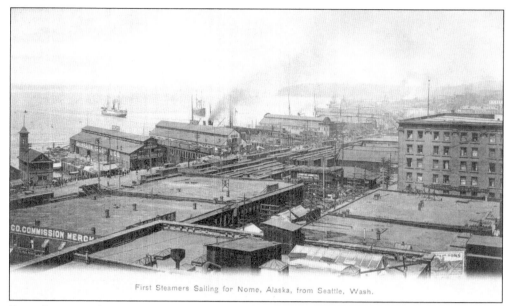

First Steamers Sailing for Nome, Alaska, from Seattle, Wash.

FIRST STEAMERS SAILING FOR ALASKA, 1900. This *c.* 1902 postcard shows the first passenger-laden steamships leaving the Seattle waterfront for the goldfields of Nome, Alaska. Today, tens of thousands of tourists annually leave the busy Seattle waterfront on Alaska-bound cruise ships, with tourism replacing gold as a source of revenue for both Alaska and Seattle. (Courtesy author's collection.)

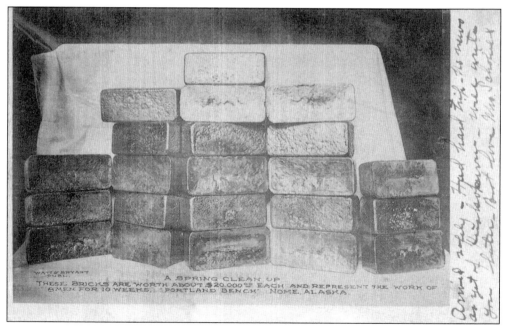

BRICKS OF GOLD, 1906. The caption below the bricks reads, "A Spring Clean Up. These bricks are worth about $20,000 each and represent the work of eight men for ten weeks. Portland bench. Nome, Alaska." At the time, $20,000 was a fortune. News accounts like this fueled the gold fever, as thousands of gold seekers poured through Seattle on their way north. (Courtesy author's collection.)

DOWNTOWN SEATTLE, LATE 1890s. This government-issued postal card (see chapter seven) looks northwest from Beacon Hill. Of particular interest is the waterfront in the foreground. All the tidal flats near the shore were subsequently filled in during the regrades, and sports stadiums and rail yards now occupy the site. (Courtesy Dan Kerlee.)

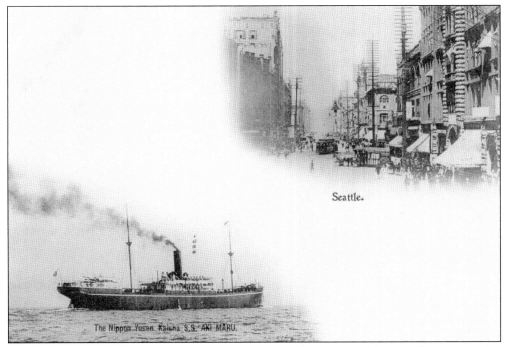

AKI MARU, C. **1903.** In 1896, the Japanese steamship *Miiki Maru* arrived in Seattle, inaugurating regularly scheduled Far East trade. The Nippon Yusen Kaisha shipping line quickly added new and larger ships to the run to handle the emerging brisk trade. This rare undivided-back Japanese postcard shows the 6,000-ton *Aki Maru*, added to the run in 1903. (Courtesy Dan Kerlee.)

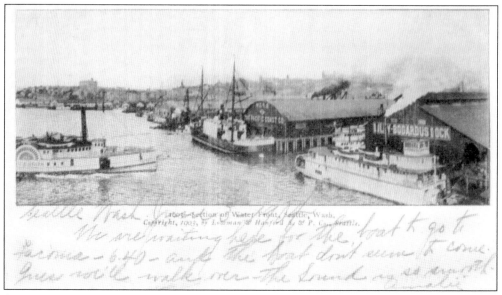

SEATTLE WATERFRONT, 1903. From Seattle's earliest days, Yesler's Wharf had been the center of commercial activity, and the growth of Yesler's Wharf mirrored the growth of the city. In 1901, the wharf was replaced by the Pacific Coast Company pier. The Pacific Coast Company was a major West Coast rail and marine conglomerate. (Courtesy Kent and Sandy Renshaw.)

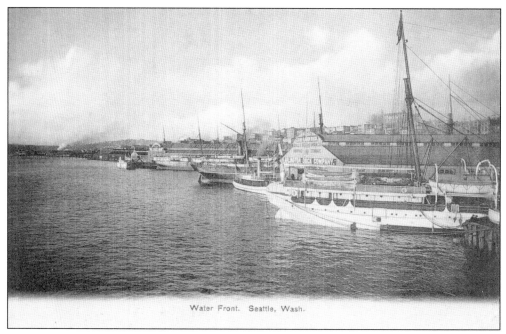

SEATTLE WATERFRONT, MID-1900s. In the foreground is Pier 6, which is now Pier 57 and known as the Bay Pavilion. John B. Agen, whose name is seen on the upper part of the end of the storage shed, was the founder of the Alaska Butter and Cream Company, supplier of food products to the Klondike and Alaskan gold fields. The Arlington Dock Company was a major West Coast agent for steamships carrying passengers to Alaska and Europe. (Courtesy Kent and Sandy Renshaw.)

38

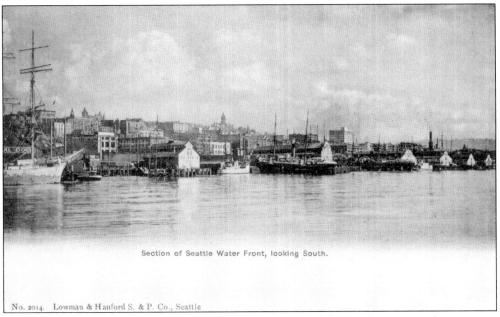

Section of Seattle Water Front, looking South.

No. 2014. Lowman & Hanford S. & P. Co., Seattle

SEATTLE WATERFRONT LOOKING SOUTH, 1900s. Tall-masted ships and Mosquito Fleet steamers crowd the north-central waterfront in this view. In the center is Schwabacher's Wharf where the SS *Portland* landed in 1897, triggering the Klondike Gold Rush. The old King County Courthouse looms high on First Hill, also known as "Profanity Hill," in the center background. (Courtesy Kent and Sandy Renshaw.)

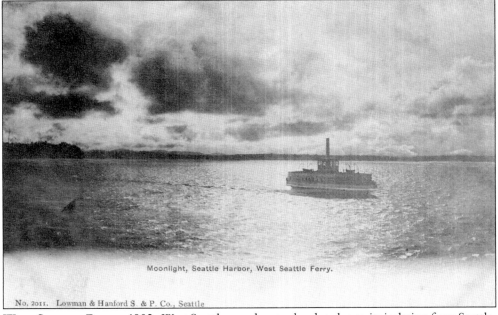

Moonlight, Seattle Harbor, West Seattle Ferry.

No. 2011. Lowman & Hanford S. & P. Co., Seattle

WEST SEATTLE FERRY, 1902. West Seattle was slow to develop due to its isolation from Seattle. The West Seattle Ferry service was established in 1889, and the area blossomed as a picnic haven and recreation destination. By 1902, the Alki Beach area had become so popular that an electric street railway was built on a trestle across the tidal flats at the southern end of Elliott Bay and the ferry service was discontinued. (Courtesy author's collection.)

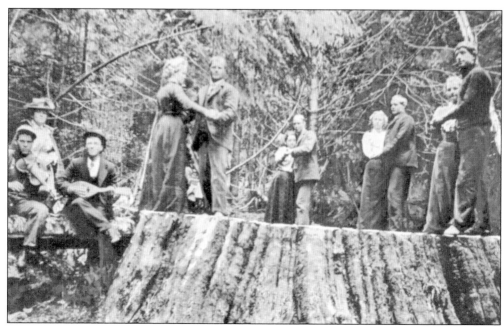

DANCING ON A TREE STUMP, 1904. Western Washington's huge trees and tree stumps, always a source of fascination to people, were put to a variety of uses: as cabins, speaker's platforms, and roadside attractions. Here a giant stump serves as a dance floor. Note how well dressed the participants are. (Courtesy Dan Kerlee.)

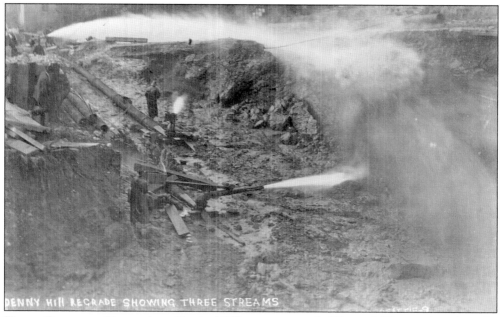

DENNY HILL REGRADE SHOWING THREE STREAMS

DENNY REGRADE. City engineer Reginald Thompson regarded Denny Hill as an obstacle to the natural northward expansion of the city. He arranged to have it completely removed in phases, much of it during 1902–1911. Over 30 blocks of level ground were created. The dirt was used to fill in the tidal flats. (Courtesy Kent and Sandy Renshaw.)

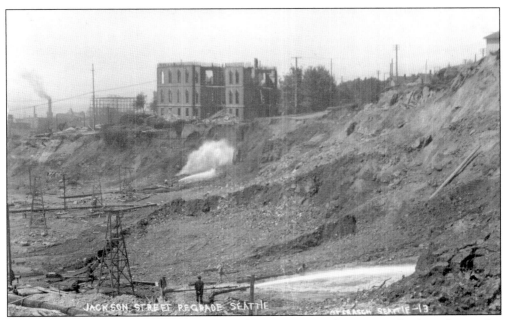

JACKSON STREET REGRADE. The extensive Jackson Street regrade was second only to the massive Denny Hill regrade in scope. Over five million cubic yards of earth were removed. Much of the material was used as fill in the Pioneer Square neighborhood, where some areas were raised as much as 43 feet. (Courtesy Kent and Sandy Renshaw.)

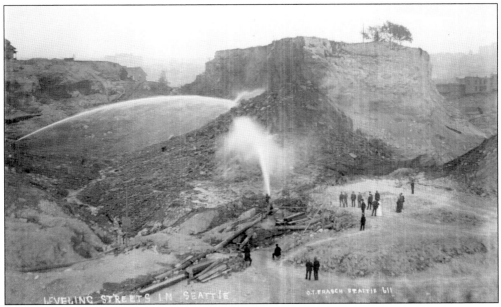

LEVELING STREETS IN SEATTLE, 1900s. This image shows the original grade of this section of the Denny regrade. Note the houses on the left sitting isolated and island-like above the landscape. The Denny Hill regrade proceeded in stages from 1899 to 1930. (Courtesy Kent and Sandy Renshaw.)

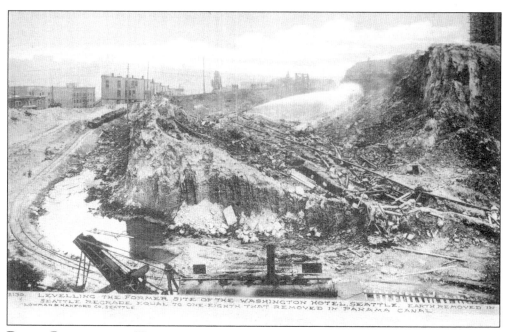

DENNY REGRADE AND WASHINGTON HOTEL, 1906. The caption says, "Leveling the former site of the Washington Hotel Seattle. Earth moved in Seattle Regrade equal to one eighth that removed in the Panama Canal." (Courtesy Kent and Sandy Renshaw.)

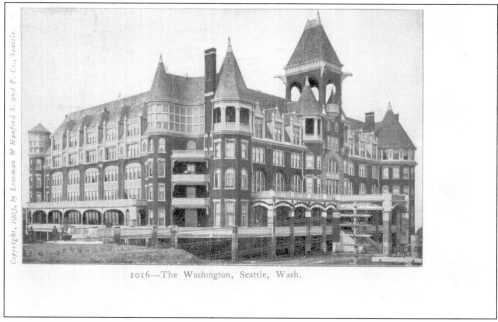

HOTEL WASHINGTON, 1903. The Hotel Washington was formerly called the Denny Hotel and boasted a magnificent view. Caught up in the turmoil following the Panic of 1893, the hotel sat vacant for 10 years before being open for a short time. This undivided-back postcard is postmarked 1906, the same year the hotel was demolished. (Courtesy author's collection.)

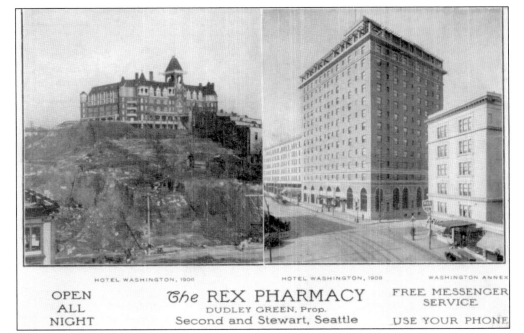

HOTEL WASHINGTON BEFORE AND AFTER. This advertising postcard shows the old Hotel Washington sitting high atop Denny Hill as it is being regraded out of existence, and the new Hotel Washington sitting on level ground. The grand old Hotel Washington was only open a year or two. (Courtesy Robin Shannon.)

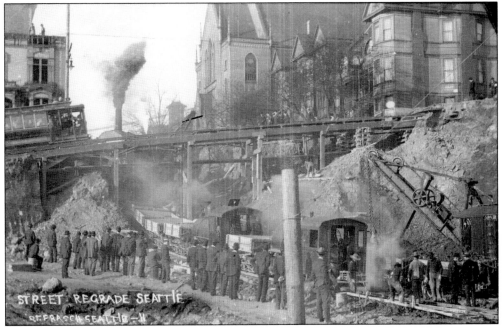

FOURTH AVENUE REGRADE, OCTOBER 1907. The Fourth Avenue regrade involved 40 acres, 1.7 miles of street, and 540,000 cubic yards of earth. This image shows how life went on around the dirt removal. Salvaged buildings were placed on blocks and either moved or lowered. Note the additional blocks supporting the trolley tracks at right. (Courtesy Kent and Sandy Renshaw.)

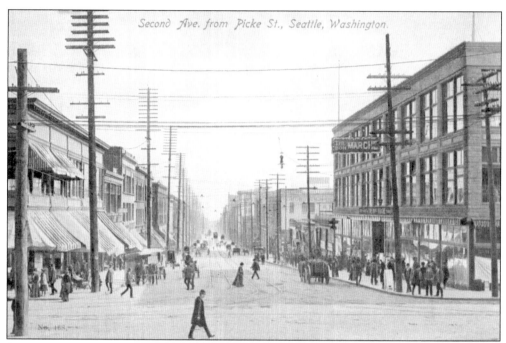

Second Ave. from Picke St., Seattle, Washington.

No. 168

SECOND AVENUE FROM PIKE, 1900s. In 1896, the Bon Marche moved from a small storefront at First Avenue and Cedar Street to Second and Pike. Known for its service and quality, the Bon advertised itself as the largest department store on the West Coast. (Courtesy Kent and Sandy Renshaw.)

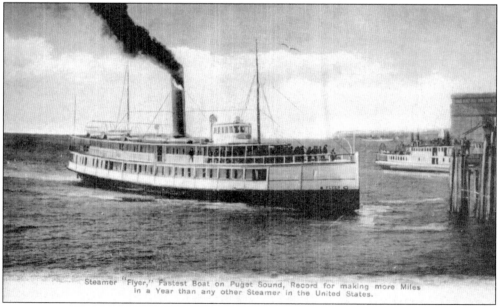

Steamer "Flyer," Fastest Boat on Puget Sound, Record for making more Miles in a Year than any other Steamer in the United States.

THE STEAMER *FLYER*, *C.* 1905. One of the most famous boats in Puget Sound's "Mosquito Fleet" was the *Flyer*. The steamer began service between Seattle and Tacoma in 1891 and spent 21 years on the route. The caption reads, "Steamer Flyer, Fastest Boat on Puget Sound, Record for making more Miles in a Year than any other Steamer in the United States." (Courtesy Kent and Sandy Renshaw.)

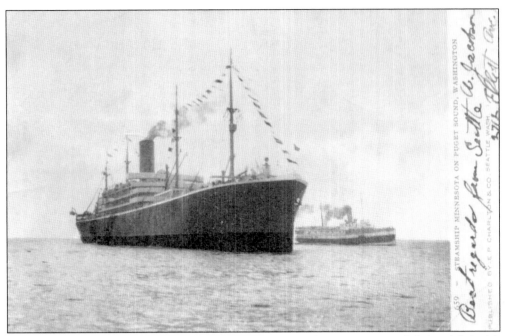

SS MINNESOTA, c. 1905. On January 22, 1905, the steamship SS *Minnesota* left Seattle's Smith Cove with the largest Asia-bound cargo to date. The Minnesota was the biggest passenger ship sailing the Pacific Ocean at the time. This undivided-back card was mailed from Seattle to Nome in 1907. (Courtesy author's collection.)

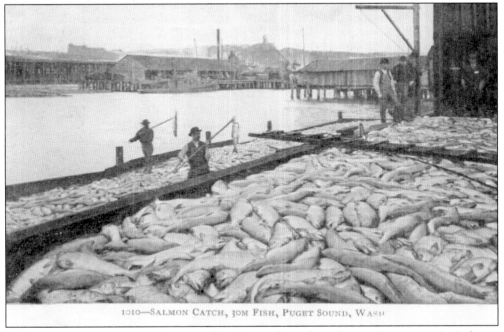

SALMON CATCH, 1905. From the time of the first settlers, salmon harvesting was a major industry in Seattle. Puget Sound and the rivers that flowed into it were teeming with salmon in Seattle's early days. This caption reads, "Salmon Catch, 30M [thousand] Fish, Puget Sound, Wash." Note the large size of many of these fish. (Courtesy author's collection.)

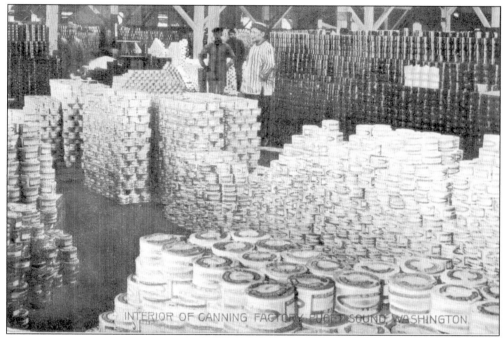

SALMON CANNERY, C. 1909. The work force in early Seattle salmon canneries was largely Chinese. In 1903, Seattle inventor Edmund Smith ingeniously developed a machine that cleaned salmon far more rapidly than people could. Thousands lost their jobs, but many other jobs persisted in warehousing, shipping, and other cannery activities. (Courtesy Dan Kerlee.)

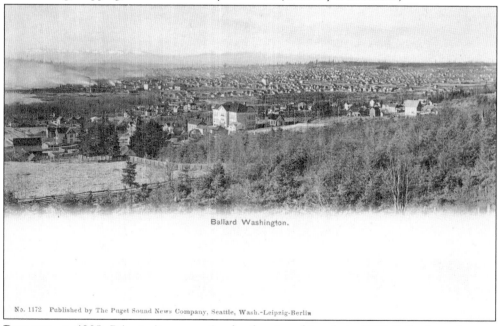

Ballard Washington.

No. 1172 Published by The Puget Sound News Company, Seattle, Wash.-Leipzig-Berlin

BALLARD, C. 1905. Prior to its annexation by the city of Seattle in 1907, Ballard was its own incorporated city, prosperous, and easily accessible from Seattle. World famous for its shingle mills clustered along the Lake Union waterfront, it was called "the shingle capital of the world." (Courtesy Kent and Sandy Renshaw.)

KING STREET STATION.
Seattle's King Street
Station opened on May
10, 1906. Ornate, with
an opulent interior, it
was the terminal for both
the Northern Pacific
and Great Northern
Railroads. Its tower, or
campanile, was modeled
after the campanile in St.
Mark's Square in Venice,
Italy, and showcased
Seattle's growing wealth
and influence. (Courtesy
author's collection.)

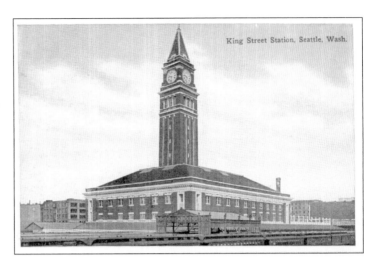

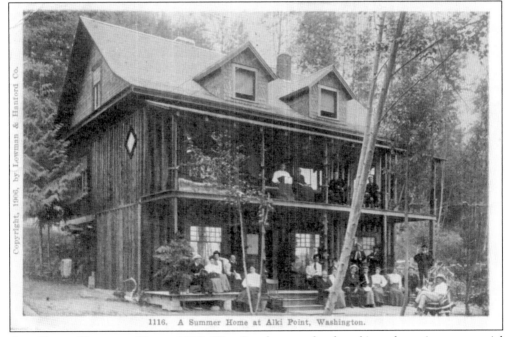

ALKI BEACH VACATION HOME, 1906. West Seattle never developed into the major commercial center that the founders had hoped. But by the late 1800s, it had developed into an extremely popular vacation spot. The long, picturesque sandy beach with its expansive view is still one of the city's most popular beaches. Note the lack of any handrail on the upper deck in this image. (Courtesy author's collection.)

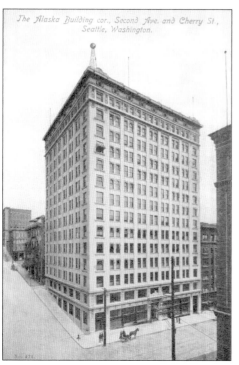

ALASKA BUILDING, c. 1904. The Alaska Building at Second Avenue and Cherry Street was built to memorialize the significance to Seattle of Alaska and the Gold Rush. It was Seattle's first steel-frame building and is considered Seattle's first skyscraper. The front door featured a large inset gold nugget. (Courtesy Kent and Sandy Renshaw.)

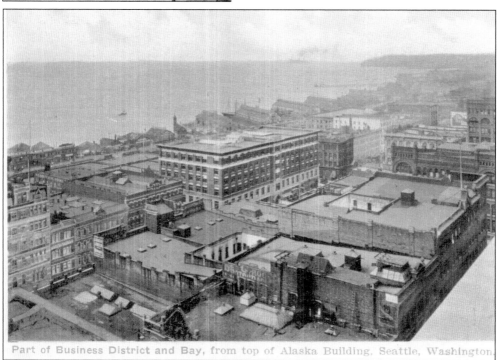

VIEW FROM TOP OF ALASKA BUILDING, 1906. The perspective is to the northwest in this undivided-back postcard. The recently realigned docks show their new east-west orientation. Magnolia Bluff rises in the background. The Alaska Club formerly met on the top floor of the Alaska Building and enjoyed this scene. (Courtesy author's collection.)

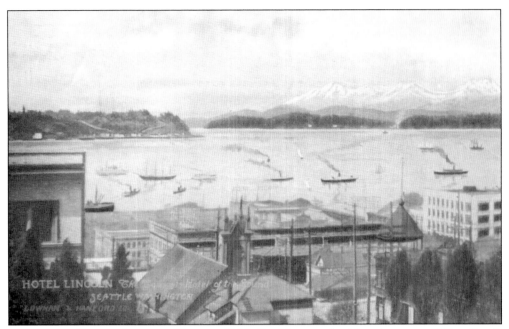

VIEW FROM TOP OF LINCOLN HOTEL, 1906. In this scene looking due west, Elliott Bay is crowded with tall ships, steamers, and sailboats. In the background, Duwamish Head in West Seattle is still partially forested and to the right the rugged, snowcapped Olympic Mountains dominate the horizon. (Courtesy author's collection.)

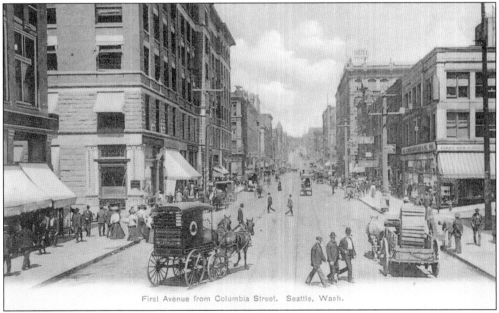

First Avenue from Columbia Street. Seattle, Wash.

FIRST AVENUE FROM COLUMBIA, 1900s. During the development boom that followed the Alaska Gold Rush, Seattle's commercial district spilled north from Pioneer Square along First Avenue. The commercial district had originally been largely south of Yesler Way. Columbia Street is two blocks north of Pioneer Square. (Courtesy Kent and Sandy Renshaw.)

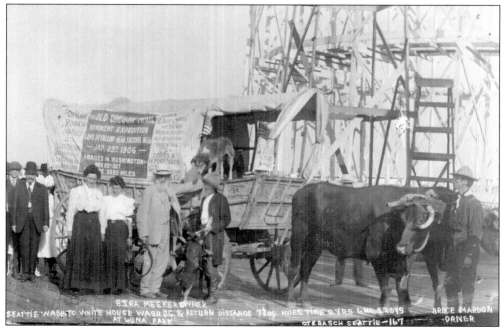

EZRA MEEKER, 1906. Puget Sound pioneer Ezra Meeker traveled the Oregon Trail in 1852, settled in the Puyallup Valley, and founded the town of Puyallup. In January 1906, he departed on a round-trip journey in a covered wagon, retracing his steps to publicize efforts to preserve the historic trail. (Courtesy Dan Kerlee.)

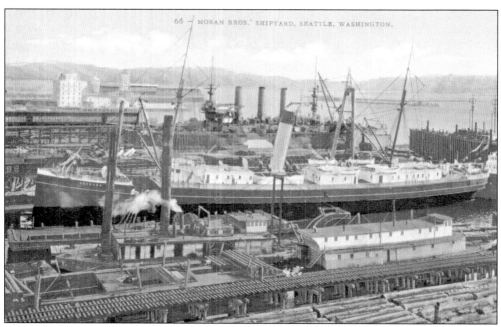

MORAN BROTHERS SHIPYARD, 1900s. After his marine repair shop on Yesler's Wharf burned in the 1889 fire, Robert Moran joined with his brothers and founded Moran Brothers Company, a shipyard. They prospered during the Klondike and Alaska Gold Rushes and went on to become one of Seattle's largest shipyards. (Courtesy Robin Shannon.)

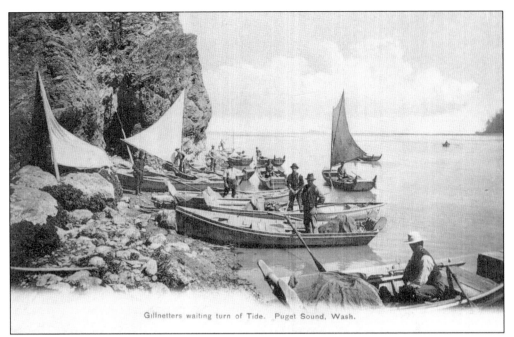

GILLNETTERS ON PUGET SOUND, 1900s. This undivided-back postcard is postmarked 1907 and was published by the Puget Sound News Company in Seattle. Note the specially designed bows, and the nets and floats heaped in the boats. The caption reads, "waiting for the turn of the tide." (Courtesy author's collection.)

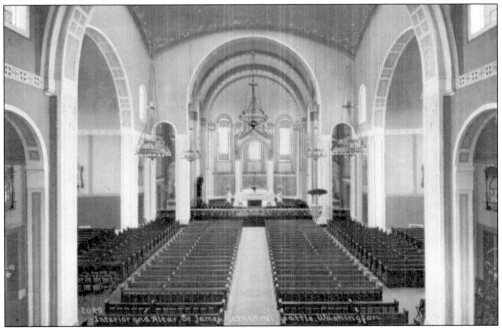

ST. JAMES CATHEDRAL INTERIOR, C. 1907. Seattle's premier Roman Catholic church was built on First Hill and dedicated on December 22, 1907. The beautiful Italian Renaissance structure featured a large, ornate, central dome and two towering spires. The dome collapsed during the famous snow of February 2, 1916, and was never rebuilt. (Courtesy author's collection.)

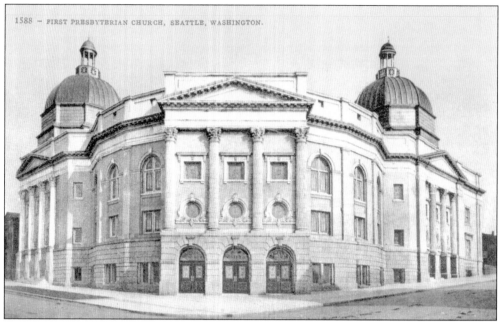

SEATTLE FIRST PRESBYTERIAN CHURCH, C. 1907. Under the leadership of the fiery and charismatic fundamentalist pastor Mark Matthews, Seattle First Presbyterian Church on Capitol Hill went on to become the largest Presbyterian church in the world, with nearly 10,000 members, 11 assistant pastors, 26 branches, and 110 elders. (Courtesy author's collection.)

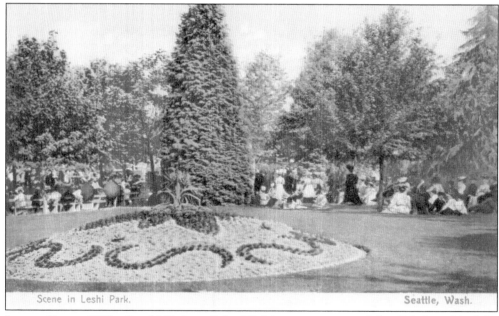

Scene in Leshi Park.　　　　　　　Seattle, Wash.

LESCHI PARK, 1900s. Leschi Park on Lake Washington was named for Chief Leschi of the Nisqually Tribe. Initially friendly toward the pioneers, Leschi became embittered after the 1854 Medicine Creek Treaty and participated in the short-lived 1856 war, during which Native Americans attempted to drive away the settlers. The park was formerly one of Leschi's favorite campgrounds. (Courtesy Kent and Sandy Renshaw.)

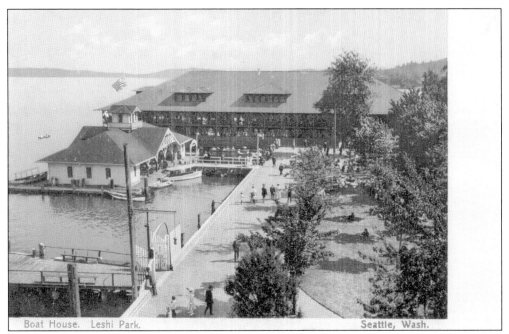

Boat House. Leshi Park. Seattle, Wash.

LESCHI PARK BOATHOUSE, 1900s. Leschi Park was established in 1889 at the eastern end of the Yesler Way cable car run. Enormously popular, the park eventually had a boathouse, a zoo, gardens, a pavilion, and a ferry service that accessed the communities on the east side of Lake Washington. (Courtesy Kent and Sandy Renshaw.)

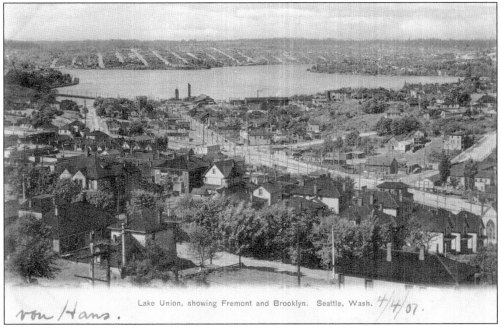

Lake Union, showing Fremont and Brooklyn. Seattle, Wash. 4/4/07.

FREMONT AND BROOKLYN, 1907. Fremont began as a mill town in 1888, and was incorporated into Seattle in 1891. It was named for Fremont, Nebraska by some early developers. What used to be called Brooklyn is now the University District. Its Brooklyn Avenue still survives. (Courtesy Kent and Sandy Renshaw.)

53

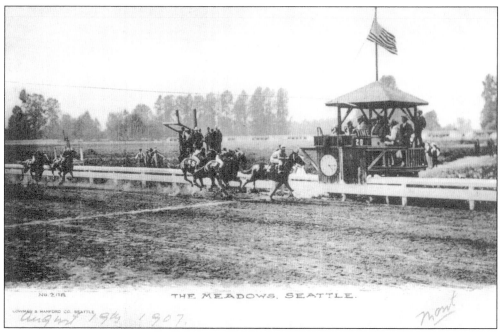

THE MEADOWS, 1907. The Meadows flourished during the 1900s as the Northwest's premier horse racing track. Built in 1902 south of Seattle, where Boeing Field now sits, it ceased operation in 1909 when the legislature banned gambling. In 1905, it was the site of the Northwest's first automobile race. (Courtesy Dan Kerlee.)

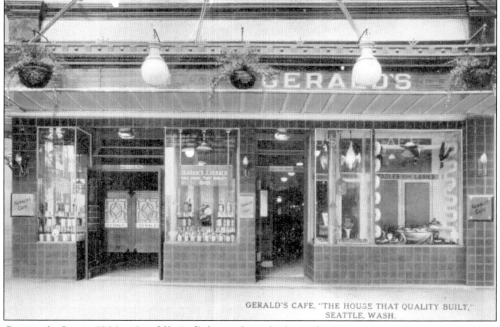

GERALD'S CAFÉ, 1900s. Gerald's Café, located inside the Colman Building at 824 First Avenue, was a popular early Seattle eatery. The owners maintained a ranch in the suburbs 10 miles away where they raised the poultry and produce that they served in the restaurant. (Courtesy author's collection.)

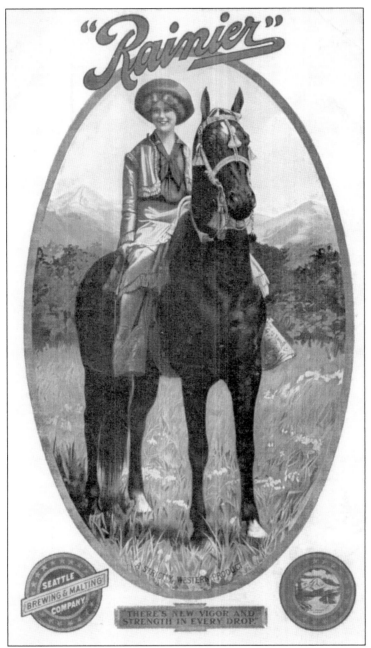

RAINIER BEER, 1900s. Andrew Hemrich founded the Seattle Brewing and Malting Company in 1878. The company's enormously successful Rainier Beer became a Northwest icon. By 1904, the brewery was the largest in the west, and by 1916 it was the sixth largest brewery in the world. In 1904, the city of Georgetown, where the sprawling brewery was located, incorporated to protect the business interests of its principal enterprise. Georgetown was annexed into Seattle in 1910. The Rainier Beer advertisement shown here played up to the sentiments of its largely Western clientele. Beneath the beautiful girl on horseback is the caption, "A Strictly Western Product." Below the picture is the slogan, "There's new vigor and strength in every drop." (Courtesy Dan Kerlee.)

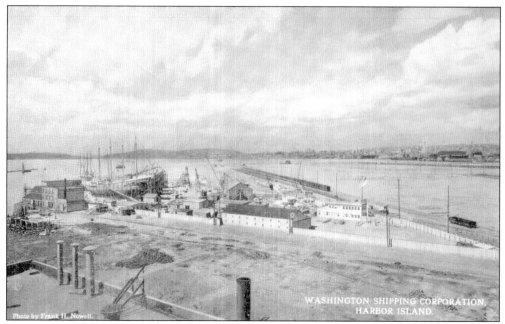

HARBOR ISLAND, 1900s. Harbor Island, located in the south end of Elliott Bay, is an artificial island. Built 1900–1909 with dredgings from the Duwamish River and fill from the Dearborn Street and Jackson Street regrades, it was for many years the largest man-made island in the world. (Courtesy Dan Kerlee.)

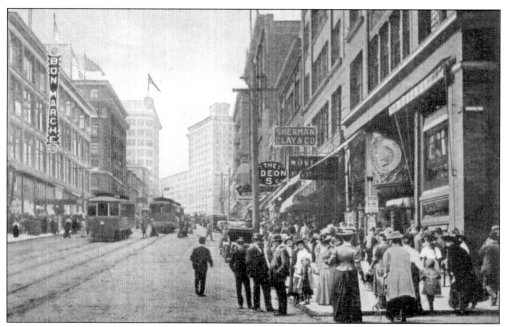

PEDESTRIANS ON SECOND AVENUE, c. 1908. It is a very well-dressed crowd in this view looking north up Second Avenue from the intersection of Union Street. Not a single adult in the whole group is without a hat. A giant Indian head penny decorates the front of the *Daily Times* building on the right. (Courtesy author's collection.)

SECOND AVENUE LOOKING NORTH, 1908.
The optimism of this era is evident from
the sign displaying Seattle's projected
population growth. The view is from Yesler
Way showing the Alaska Building and
the American Bank and Empire Building.
All buildings are masonry, reflecting
building codes adopted after the great fire
of 1889. (Courtesy author's collection.)

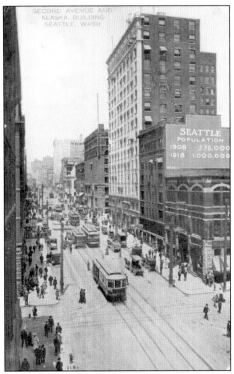

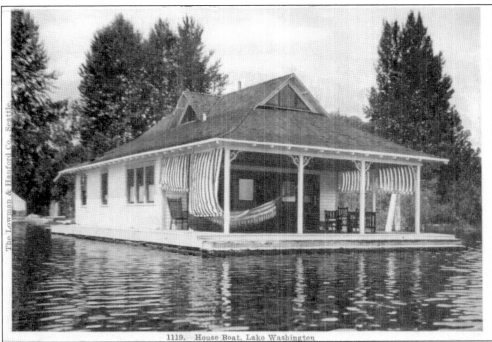

LAKE WASHINGTON HOUSEBOAT, 1908. This houseboat has a large deck facing the lake with
curtains, benches, deck chairs, and a hammock. Seattle's houseboats became nationally famous
after they were featured in the hit movie *Sleepless in Seattle*. Suddenly the whole nation fell in
love with this unique Seattle lifestyle. (Courtesy author's collection.)

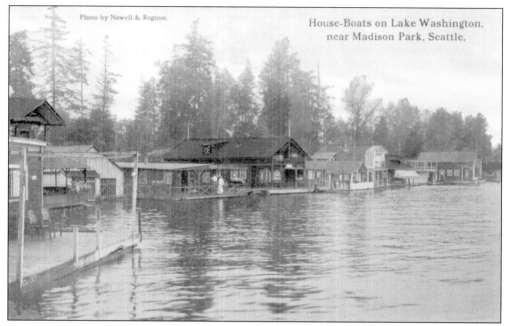

House-Boats on Lake Washington, near Madison Park, Seattle.

HOUSEBOATS ON LAKE WASHINGTON, C. 1910. Seattle's colorful houseboat communities developed early in the city's history. Despite a reputation that some houseboats were mere floating shanties, many early images show roomy, well-built structures comparable to their land-based counterparts of the day. Some of the houseboats shown here are large two-story homes. (Courtesy author's collection.)

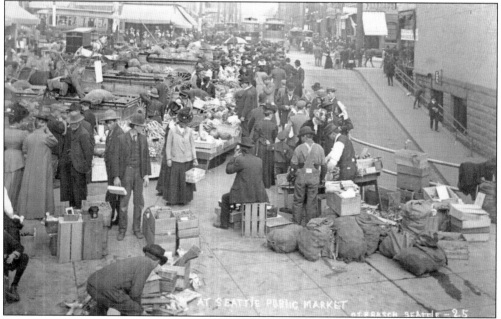

PIKE PLACE MARKET, LATE 1900s. The ability to bypass the middleman made the Pike Place Public Market an overnight hit with both farmers and consumers. In 1969, preservationists saved the market from an urban renewal plan that would have demolished it. The market still flourishes today and is now one of Seattle's major tourist attractions. (Courtesy Dan Kerlee.)

SECOND AVENUE LOOKING NORTH, 1908.
The optimism of this era is evident from the sign displaying Seattle's projected population growth. The view is from Yesler Way showing the Alaska Building and the American Bank and Empire Building. All buildings are masonry, reflecting building codes adopted after the great fire of 1889. (Courtesy author's collection.)

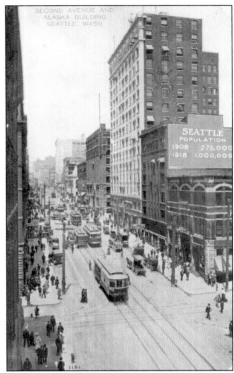

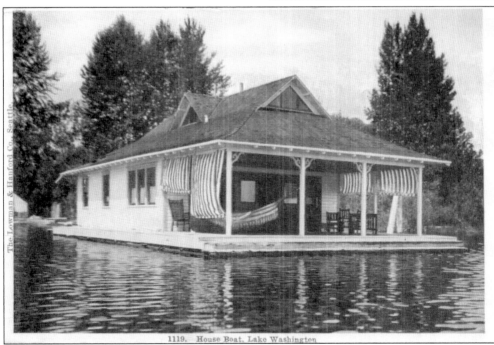

LAKE WASHINGTON HOUSEBOAT, 1908. This houseboat has a large deck facing the lake with curtains, benches, deck chairs, and a hammock. Seattle's houseboats became nationally famous after they were featured in the hit movie *Sleepless in Seattle*. Suddenly the whole nation fell in love with this unique Seattle lifestyle. (Courtesy author's collection.)

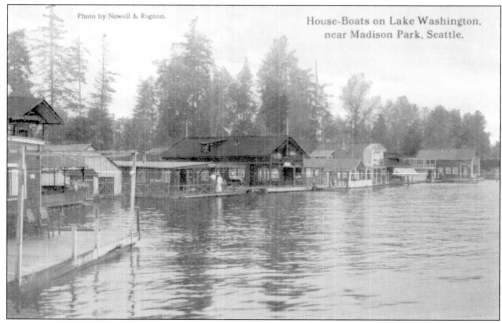

HOUSEBOATS ON LAKE WASHINGTON, C. 1910. Seattle's colorful houseboat communities developed early in the city's history. Despite a reputation that some houseboats were mere floating shanties, many early images show roomy, well-built structures comparable to their land-based counterparts of the day. Some of the houseboats shown here are large two-story homes. (Courtesy author's collection.)

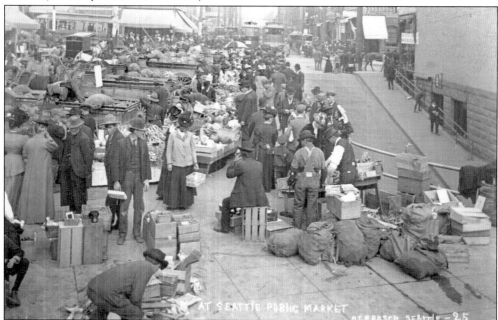

PIKE PLACE MARKET, LATE 1900s. The ability to bypass the middleman made the Pike Place Public Market an overnight hit with both farmers and consumers. In 1969, preservationists saved the market from an urban renewal plan that would have demolished it. The market still flourishes today and is now one of Seattle's major tourist attractions. (Courtesy Dan Kerlee.)

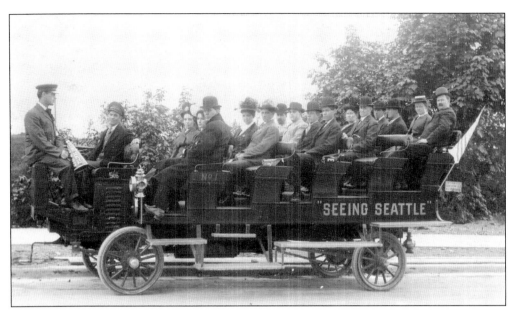

SEEING SEATTLE, 1908. The hard tires may have been bumpy in this horseless carriage, but seeing the sights around Seattle was becoming a popular pastime by the 1900s. Note how well dressed the driver, tour guide, and passengers are in this 1908 postmarked postcard. (Courtesy Dan Kerlee.)

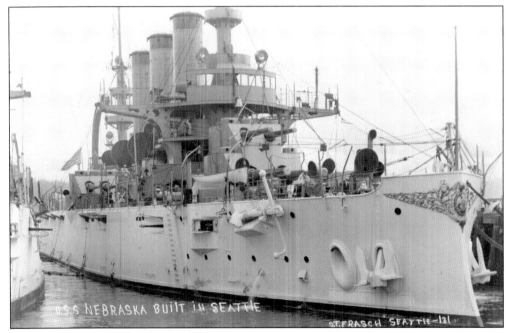

USS NEBRASKA, 1900s. In 1904, Moran Brothers Shipyard launched the steel-hulled USS *Nebraska,* hailed at the time as one of the most powerful and modern battleships in the U.S. Navy. The USS *Nebraska* joined the Great White Fleet in 1908, and went on to serve in World War I. (Courtesy Dan Kerlee.)

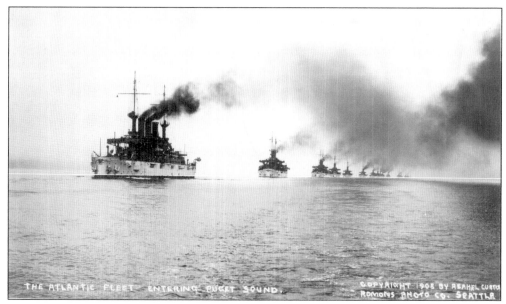

THE GREAT WHITE FLEET ENTERING PUGET SOUND, 1908. In 1907, Pres. Theodore Roosevelt sent a fleet of 16 battleships and 14,000 sailors on a 14-month trip around the globe in a flashy display of U.S. naval power. The fleet became known as the Great White Fleet due to the ship's white painted hulls. (Courtesy Dan Kerlee.)

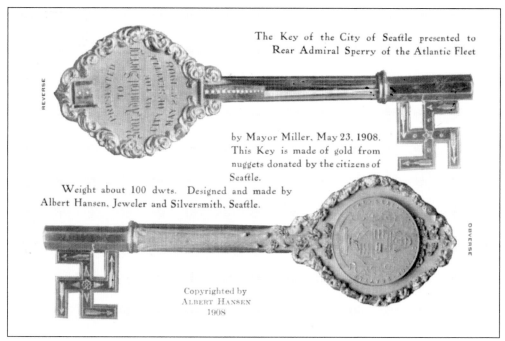

The Key of the City of Seattle presented to Rear Admiral Sperry of the Atlantic Fleet

REVERSE

by Mayor Miller, May 23, 1908. This Key is made of gold from nuggets donated by the citizens of Seattle.

Weight about 100 dwts. Designed and made by Albert Hansen, Jeweler and Silversmith, Seattle.

OBVERSE

Copyrighted by
ALBERT HANSEN
1908

KEY TO THE CITY, 1908. On May 23, 1908, the Great White Fleet visited Seattle on their "goodwill trip" around the globe. A crowd of 300,000 enthusiastic citizens watched the welcoming parade. Mayor Miller presented Rear Admiral Sperry with this ornate key to the city cast from Klondike gold nuggets donated by city residents. Before the rise of the Nazis, the swastika was a common and benign symbol. (Courtesy Dan Kerlee.)

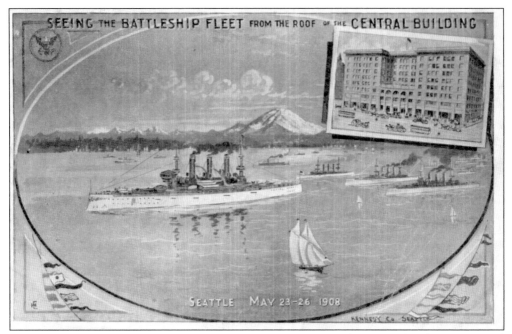

GREAT WHITE FLEET FROM CENTRAL BUILDING ROOF, 1908. The Central Building on Third Avenue between Columbia and Marion Streets had just been built when the Great White Fleet visited Seattle. This card promoted seeing the fleet from the rooftop viewing platform. (Courtesy Dan Kerlee.)

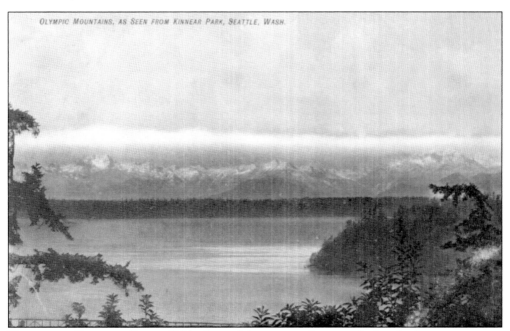

VIEW FROM KINNEAR PARK, 1908. Some things never change. The handwritten message on the back of this card says, "A job at last. Am working for the Robinsons that run the mill." Kinnear Park is on the west side of Queen Anne Hill and offers sweeping views of Elliott Bay, Puget Sound, and the Olympic Mountains. (Courtesy author's collection.)

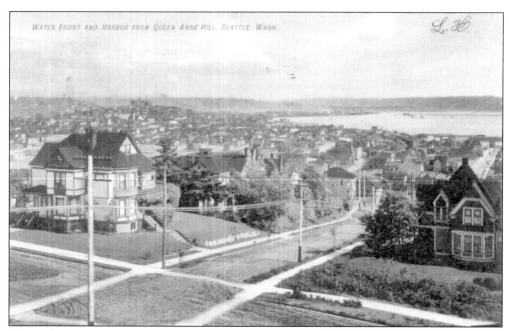

QUEEN ANNE HILL RESIDENCES, 1908. Seattle's prosperity is evident in this image of a residential neighborhood on Queen Anne Hill north of downtown. There are large, attractive, comfortable homes, manicured lawns, wide streets, and paved sidewalks. Except for the unpaved roads, the scene is little changed from many parts of Queen Anne Hill today. (Courtesy author's collection.)

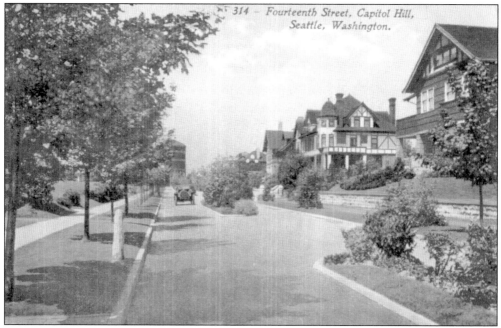

CAPITOL HILL RESIDENCES, 1909. This scene shows another prosperous early Seattle neighborhood. Note again the large attractive homes, curbs and sidewalks, and landscaped planter strips. The streets are still unpaved in this image. Capitol Hill is immediately east of downtown and was easily accessible for early Seattle residents. (Courtesy author's collection.)

OLD AND NEW CITY HALLS, 1909. Between 1891 and 1909, the Seattle city offices occupied the former King County Courthouse on Third Avenue between Yesler Way and Jefferson Street. The previous city hall burned down in the Great Fire of 1889. The 1891–1909 location earned the name of "Katzenjammer Castle" for its hodgepodge of multiple additions. (Courtesy Dan Kerlee.)

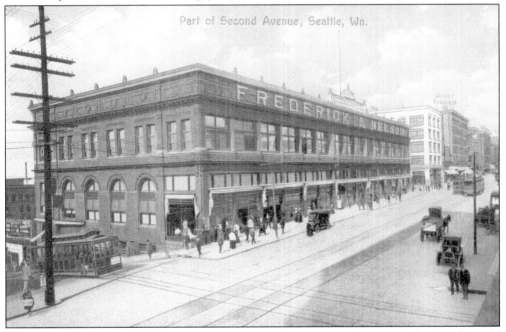

FREDERICK AND NELSON, 1909. Frederick and Nelson was another one of Seattle's historic department stores. Founded in 1890 by Donald Frederick and Nels Nelson, "Frederick's" was known for its first-class customer service. In 1911, it moved from this Second Avenue location to a larger six-story building at Fifth Avenue and Pine Street. (Courtesy Dan Kerlee.)

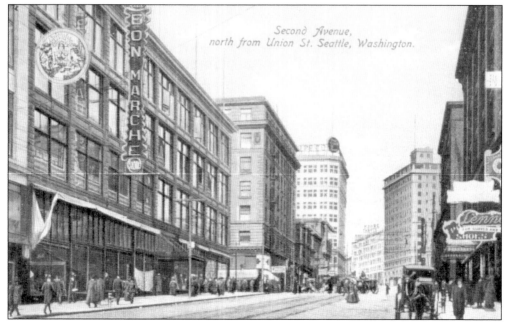

BON MARCHE, 1909. There are horses and buggies on the street but the latest fashions inside in this view of Seattle's premier luxury department store seen on the left. The view is looking north up Second Avenue. Note the official AYPE logo in upper left corner. The tall buildings in the background are where Denny Hill stood just a few years before. (Courtesy author's collection.)

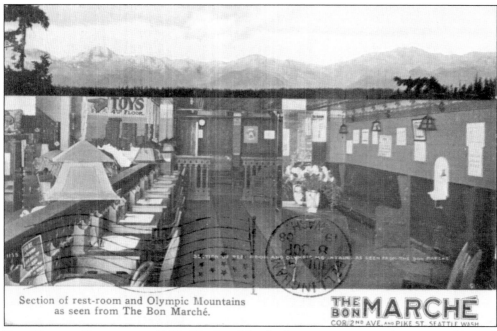

Section of rest-room and Olympic Mountains as seen from The Bon Marché.

THE BON MARCHÉ
COR. 2ND AVE. AND PIKE ST. SEATTLE WASH.

BON MARCHE RESTROOMS, 1908. The Bon Marche department store at the corner of Second Avenue and Pike Street was so elegant that even its plush restrooms were depicted on postcards. The upper image shows the view toward the Olympic Mountains as seen from the Bon. (Courtesy author's collection.)

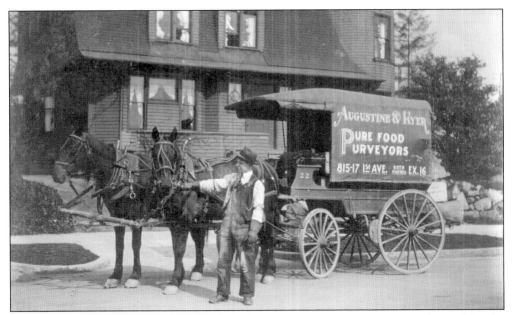

HOME DELIVERY, 1909. Augustine and Kyer was a popular grocery store located in the Colman Building on First Avenue between Columbia and Marion Streets. It maintained a large horse and buggy fleet for home delivery. It also operated a large store on Queen Anne Hill at Queen Anne Avenue and Galer Street. (Courtesy Dan Kerlee.)

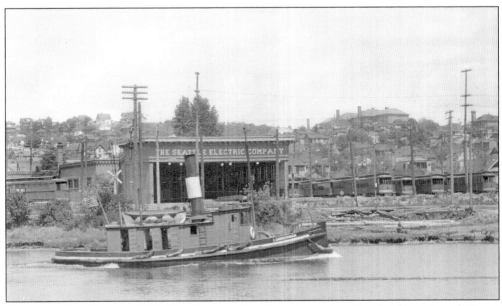

FREMONT CAR BARN, 1909. The Fremont Car Barn, located at North Thirty-Fourth Street and Phinney Avenue North at the far east end of Salmon Bay, was a headquarters for Seattle's fleet of streetcars. Called here the Seattle Electric Company, the enterprise became the Seattle Municipal Railway. (Courtesy Dan Kerlee.)

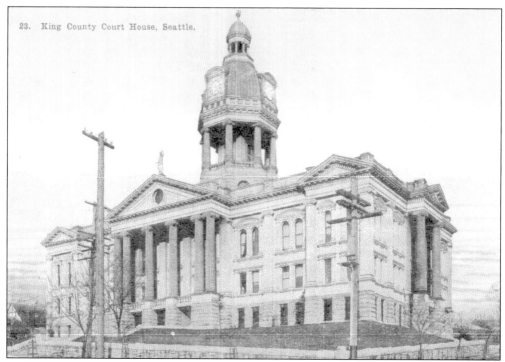

23. King County Court House, Seattle.

OLD KING COUNTY COURTHOUSE, POSTMARKED 1909. The old King County Courthouse (1890–1930) was famous for its overly ornate tower and its position high atop First Hill, also known as "Profanity Hill" due to its extremely steep grade. The Harborview Hospital complex now occupies the site. (Courtesy author's collection.)

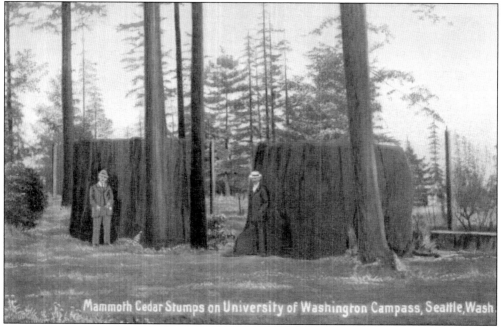

Mammoth Cedar Stumps on University of Washington Campass, Seattle,Wash.

UNIVERSITY OF WASHINGTON STUMPS, C. 1900s. This image illustrates the enormity of the old growth trees that used to cover the Seattle area. (Courtesy Dan Kerlee.)

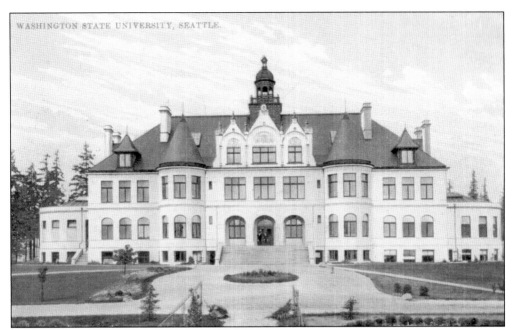

DENNY HALL, 1908. The first building to be built on the University of Washington campus was the former administration building, now called Denny Hall. It was constructed in 1895 in French Renaissance style using Tenino sandstone from Tenino, Washington. Many early postcards refer to the University of Washington as Washington State University.

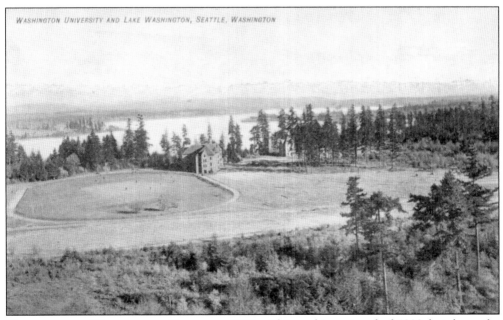

UNIVERSITY OF WASHINGTON GROUNDS, 1900s. This card is postmarked 1909, but shows the University of Washington grounds earlier in the decade before the development related to the Alaska-Yukon-Pacific Exposition. The handwritten message on the reverse reads, "I am sending you a paper that will tell you of the growth of a prosperous city that has known no hard times." (Courtesy Dan Kerlee.)

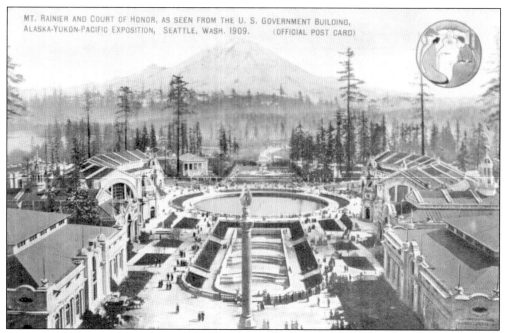

ALASKA-YUKON-PACIFIC EXPOSITION GROUNDS, 1909. This view looks south over the fairgrounds, now incorporated into the University of Washington campus. The elaborate exposition was planned as a commercial venture to publicize the close ties between Seattle, Alaska, the Yukon Territory and the Far East, and to attract investors and business. (Courtesy author's collection.)

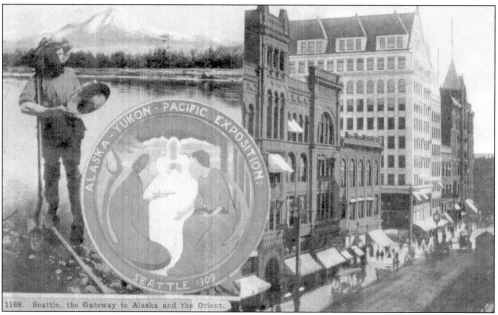

AYPE MULTIVIEW, 1909. This card showing an Alaskan gold miner on the left, a Seattle street scene on the right, and the official logo of the AYPE was intended to illustrate the connections between Seattle, Alaska, and the Orient. The fair was organized by people who had either been to Alaska or profited from business dealings with Alaska. (Courtesy author's collection.)

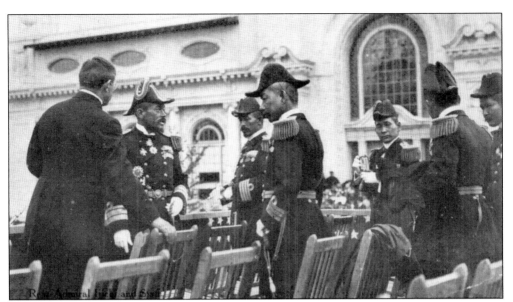

JAPANESE NAVAL DELEGATION AYPE. The reverse of this card reads, "Rear Admiral Hikojiro Ijichi and staff at the Exposition. The visit of the Admiral, at the opening of the Exposition, with the Japanese ships, lying in Seattle's harbor, was a pleasant incident in the line of international courtesies." (Courtesy author's collection.)

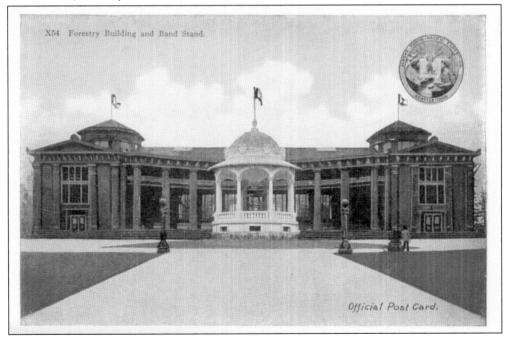

FORESTRY BUILDING AT THE AYPE. The impressive forestry building at the 1909 Alaska-Yukon-Pacific Exposition incorporated many details which resembled classical architecture, only all done with enormous trees, like the massive columns across the front. All timber was provided by Washington's Snohomish County as a demonstration of that county's timber wealth. Snohomish County is directly north of King County, where Seattle is located. (Courtesy author's collection.)

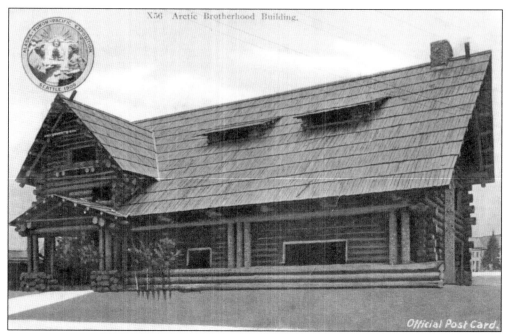

ARCTIC BROTHERHOOD HOUSE AT THE **AYPE.** Another one of several Alaska-related social organizations in early Seattle, the Arctic Brotherhood was a fraternal society whose members lived north of latitude 54 degrees 20 minutes. The manager of the Arctic Brotherhood house was Godfrey Chealander, a merchant who first proposed the concept of the AYPE. (Courtesy author's collection.)

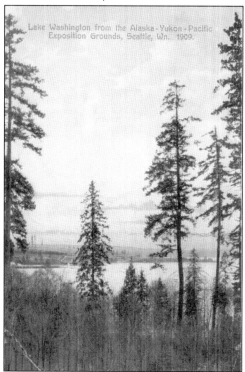

LAKE WASHINGTON FROM **AYPE GROUNDS, 1909.** This image shows the former shoreline of Lake Washington. The shoreline was radically altered when the Lake Washington Ship Canal was completed in 1917 and the lake was lowered by over nine feet. Note the viewing platform in lower left. (Courtesy author's collection.)

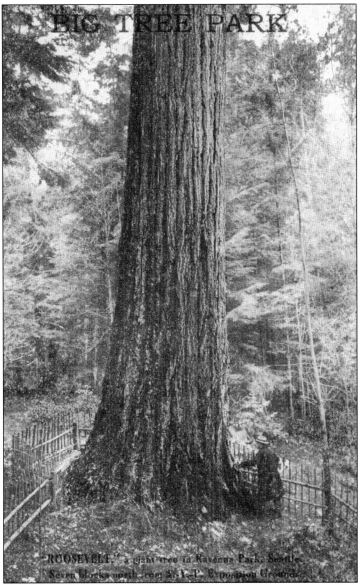

ROOSEVELT TREE AT RAVENNA PARK, 1909. Although not part of the official exposition grounds, a visit to the privately owned Ravenna Park was considered an integral part of the Alaska-Yukon-Pacific Exposition experience. Located just seven blocks from the exposition grounds, the large park was still in its undeveloped condition. The picturesque park featured a deep ravine with a large sparkling stream teeming with fish, a mineral spring, and a luxuriant old-growth forest that included numerous trees remarkable for their enormous size. Some were 300 to 400 feet in height. The Roosevelt tree, so named by city residents, was 44 feet in circumference. The park was sometimes called "Big Tree Park." The owner decorated the park with totem poles, a large Native American cedar canoe, and a wickiup, or mound-shaped Native American dwelling. AYPE publicity information played up Ravenna Park, describing how the exposition visitor could experience nature at its most sublime only minutes from the fairgrounds. Trolley car service was offered from the exposition grounds to the park every eight minutes. (Courtesy author's collection.)

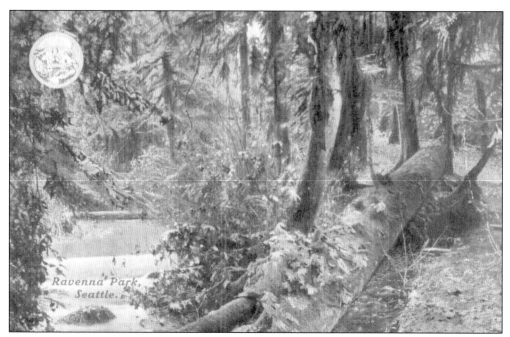

RAVENNA CREEK, 1909. In this AYPE image, Ravenna Creek splashes its way through the ravine in Ravenna Park. Note the AYPE logo in the upper left corner. Later development upstream cut Ravenna Creek off from its headwaters at Green Lake, reducing the creek to a trickle. (Courtesy author's collection.)

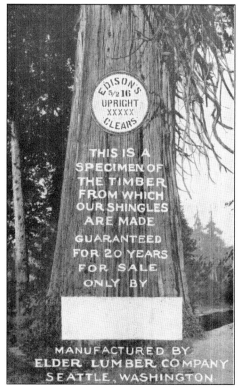

EDISON'S UPRIGHT CLEAR SHINGLES. This 1909 advertisement for Edison's Shingles looks like it could have been made today, except for the product. The forests around Seattle were filled with huge old-growth cedar trees that made straight, quality, knot-free shingles. Except for preserves, the old-growth trees have now all been logged. (Courtesy Dan Kerlee.)

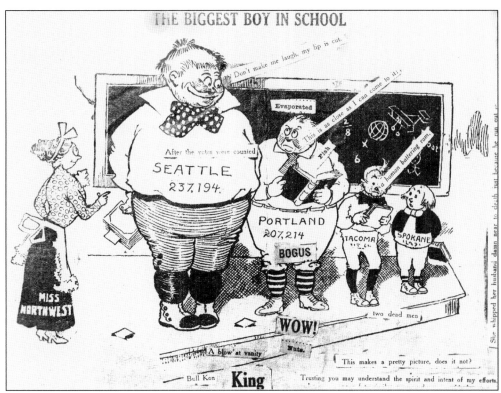

SEATTLE POPULATION, c. 1909. After its huge population boom of the 1890s and early 1900s, Seattle emerged as the largest city in the Pacific Northwest and the undisputed commercial leader. This card humorously and boastfully depicts Seattle's size relative to its leading rivals, and compares populations. (Courtesy Dan Kerlee.)

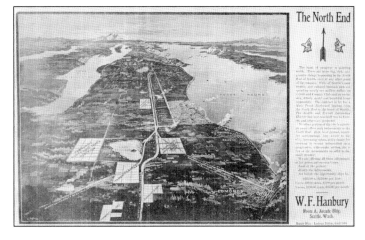

NORTH END, 1909. This remarkably prophetic card postmarked in 1909 accurately foresees the Seattle metropolitan area spilling northward as far as Shoreline, Edmonds, and Lynnwood. Landmarks such as Richmond Beach, Lake Ballinger, and Halls Lake are shown. Land prices are a mere $125 to $250 per acre. (Courtesy Dan Kerlee.)

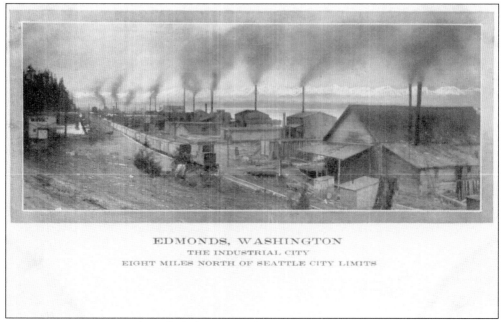

EDMONDS, WASHINGTON
THE INDUSTRIAL CITY
EIGHT MILES NORTH OF SEATTLE CITY LIMITS

EDMONDS, 1909. As Seattle exploded in size in the 1890s and 1900s, so did its adjacent suburban communities. Edmonds was founded in 1890, and was known for the shingle mills that lined its Puget Sound waterfront. It was easily accessible from Seattle by both boat and train. (Courtesy Ed Weum.)

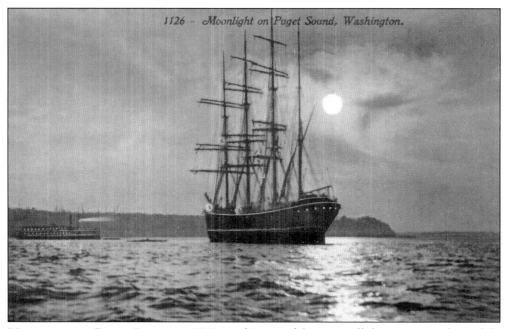

1126 – Moonlight on Puget Sound, Washington.

MOONLIGHT ON PUGET SOUND, c. 1909. In this peaceful scene a tall ship rests at anchor, while in the background a steamer heads away from shore. The tall ship is illuminated by lanterns, while a large headlight on the steamer guides its way. (Courtesy author's collection.)

Four

ROARING TEENS
AND TWENTIES

The boom of the previous two decades persisted as businesses expanded, subdivisions proliferated, and new residents continued to pour into the prospering city. Seattle again celebrated its ties to the Far North when it held its first annual Golden Potlatch in 1911. The 42-story Smith Tower opened in 1914, and stood for years as the tallest building west of the Mississippi and a symbol of civic pride. Downtown construction maintained its brisk pace in the 1910s. The number of automobiles increased rapidly, and in 1915 the state began issuing metal license plates. By 1921, the state had almost 200,000 automobiles on the road, up from 760 in 1906. Good roads became an important public policy issue.

It seemed the sky was the limit for the city's prospects when the first Boeing aircraft took to the air in 1916. Prohibition began in Washington in 1916, four years ahead of the rest of the country. The law was widely disregarded and Seattle police lieutenant Roy Olmstead became a local folk hero when he was caught operating a large rum running operation in 1920. The Lake Washington Ship Canal and Ballard Locks opened in 1917, giving the fresh waters of Lake Washington and Lake Union access to the salt water of Puget Sound and the Pacific Ocean. Seattle's shipbuilding industry, which had prospered enormously from the Klondike and Alaska Gold Rushes, expanded again during World War I with some shipyards setting national records for output. The abrupt end of World War I caused short-term hardship for the Boeing Company and for the area's shipyards as wartime orders suddenly ended. Along the Lake Union waterfront, 30 unwanted surplus ships sat mothballed until they were finally burned. Seattle was the scene of the nation's first general strike on February 6, 1919, as most workers in the city walked off their jobs. Labor leaders, sensing support for the action was waning, called off the strike on February 13, 1919. The University of Washington sports stadium opened in 1920 and soon was drawing huge crowds for football games.

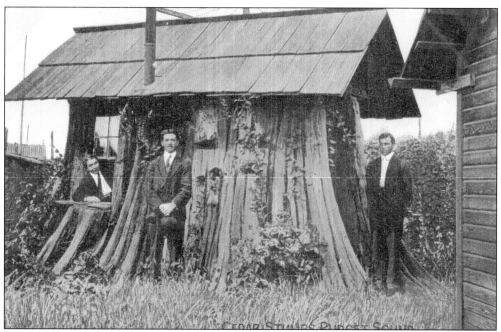

CEDAR STUMP CABIN, C. 1910. Stump cabins like this one were found throughout western Washington during the pioneer era and were actually lived in by early residents. Many early postcards show cabins made from stumps such as this one. (Courtesy author's collection.)

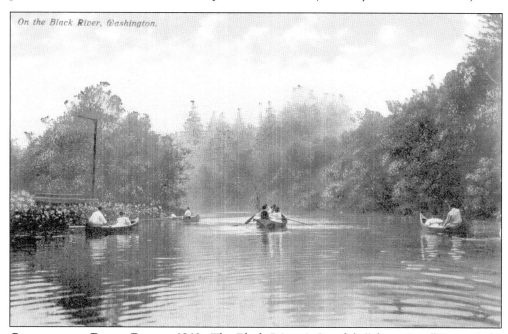

CANOEING ON BLACK RIVER, 1910. The Black River is Seattle's "ghost river." It was Lake Washington's natural outlet, running from the south end of the lake into the Duwamish River. When the ship canal from Lake Washington to Lake Union was opened in 1916, it caused the level of Lake Washington to drop by over nine feet. The Black River channel was abandoned and eventually filled in, developed, and forgotten. (Courtesy author's collection.)

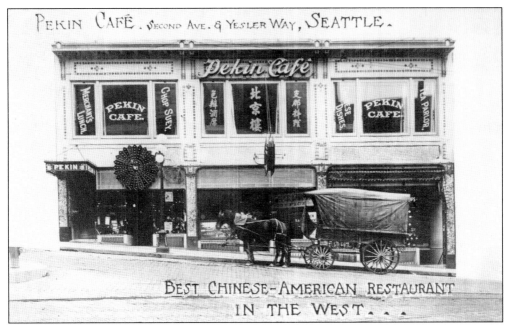

PEKIN CAFÉ, 1910. The Pekin Café in the heart of downtown was a popular Chinese eatery in its day. The handwritten message on the back of this card says, "This is the place where we got some fine Chinese eating. Come and have some noodles and Chop Suey." (Courtesy Dan Kerlee.)

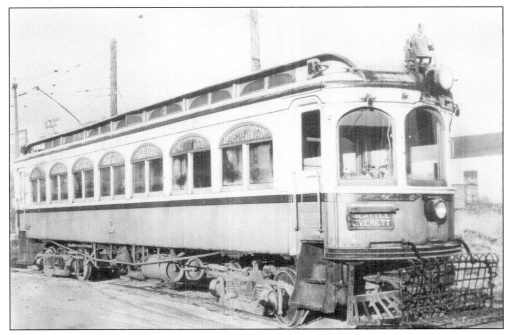

SEATTLE-EVERETT INTERURBAN, 1910. On April 30, 1910, the Seattle-Everett Traction Company began regular electric rail service between Seattle and Everett, linking the suburban communities to the north with Seattle and opening up the area for development. The line was abandoned in 1939, falling victim to the popularity of the automobile. (Courtesy Dan Kerlee.)

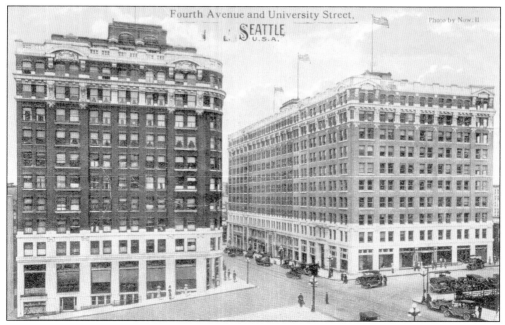

COBB BUILDING, 1910. The ornate and historic Cobb Building was famous for its Beaux Arts architecture and the large terra cotta Native American chief heads incorporated into the design. In this image, the Cobb Building is on the left and the architecturally similar White Henry Stuart Building is on the right. (Courtesy author's collection.)

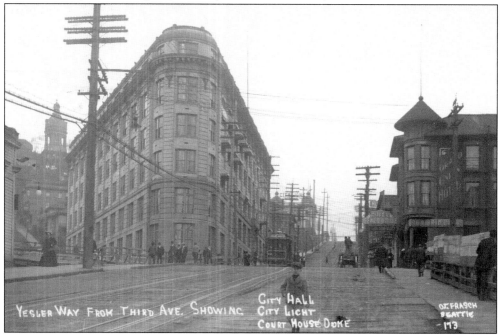

CITY BUILDINGS, c. 1910. This view looking east up Yesler Way shows the dome of the old county courthouse on the left, the recently occupied triangular City Hall building in the center, and the building of the newly created Seattle City Light just to the right of City Hall. (Courtesy Dan Kerlee.)

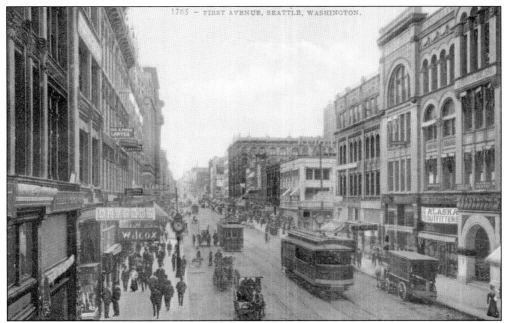

FIRST AVENUE LOOKING NORTH, 1911. All vehicles on the street except for the trolleys are still horse-drawn. Many of the business signs are readable. There are several dentists, a lawyer's office, a billiard hall, a hotel, and a clothing store. Note the large sign on the right saying "Alaska Outfitters." No wood buildings are visible. (Courtesy Kent and Sandy Renshaw.)

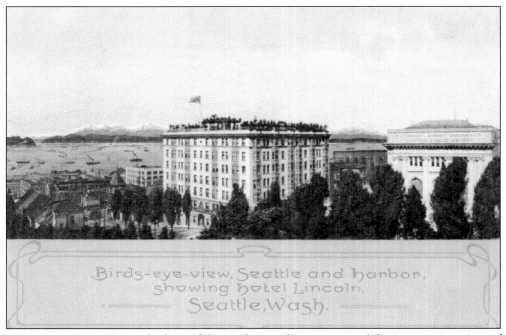

LINCOLN HOTEL, 1911. The beautiful Lincoln Hotel was renowned for its sweeping view of Puget Sound, its luxurious accommodations, and especially its rooftop garden. The hotel claimed to have the largest and finest hanging garden in the world. The Lincoln Hotel was gutted in a tragic fire in 1920. (Courtesy Dan Kerlee.)

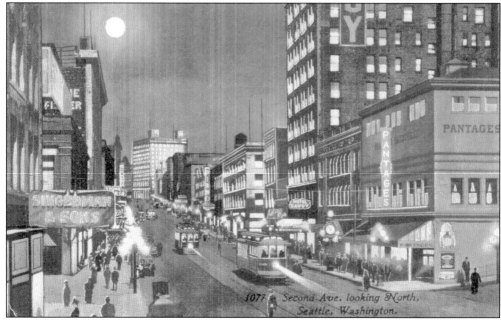

EARLY SEATTLE NIGHTLIFE. This undated postcard from the 1910s shows a lively nighttime street scene on Second Avenue. The streets are filled with people and a crowd is gathered around Seattle's original Pantages Theater, the Pantages Vaudeville, which opened in 1904. In 1915, a much larger and longer-lasting Pantages Theater was opened by theater entrepreneur Alexander Pantages. (Courtesy author's collection.)

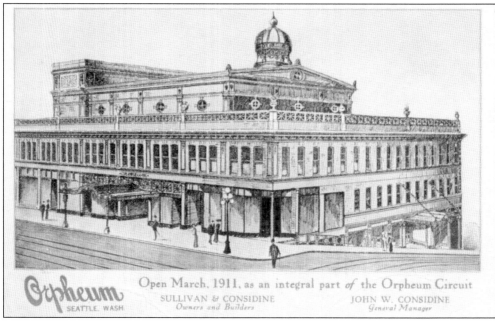

THE ORPHEUM THEATER, 1911. On May 5, 1911, the Orpheum Theater opened to great fanfare. It was famous for its lavish details and use of almost exclusively Washington State building materials. Its controversial owner, John Considine, had been tried and acquitted in the shooting death of former police chief William Meredith 10 years earlier. (Courtesy Dan Kerlee.)

THE HORSESHOE LIQUOR COMPANY, c. 1911. Vice was king in early Seattle. Saloons, gambling houses, and brothels flourished, especially during the Alaska Gold Rush. The Horseshoe Liquor Company was a popular saloon and restaurant at 709 First Avenue near Pioneer Square. It billed itself as "A Resort for Gentlemen." (Courtesy Dan Kerlee.)

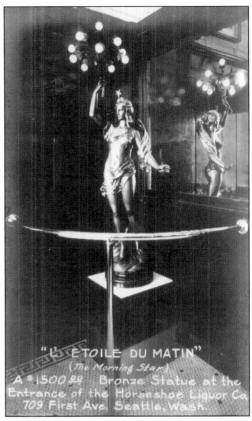

"L'ETOILE DU MATIN" (The Morning Star) A #1500ºº Bronze Statue at the Entrance of the Horseshoe Liquor Co. 709 First Ave. Seattle, Wash.

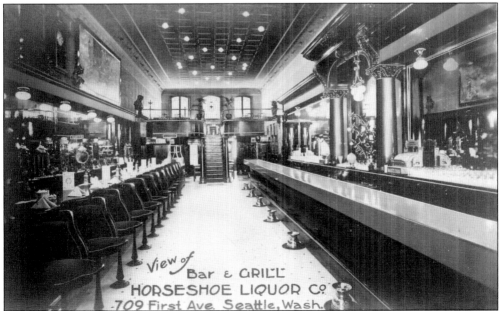

View of Bar & GRILL HORSESHOE LIQUOR Cº 709 First Ave. Seattle, Wash.

HORSESHOE LIQUOR COMPANY BAR AND GRILL, c. 1911. This image shows the very comfortable surroundings inside the bar. Note the tastefully folded napkins on the counter on the left side and the spittoons on the right side of the aisle. (Courtesy Dan Kerlee.)

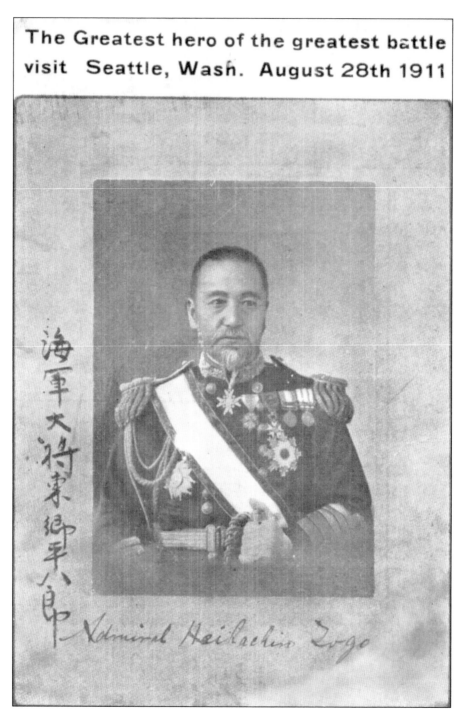

The Greatest hero of the greatest battle visit Seattle, Wash. August 28th 1911

海軍大将東郷平八郎

Admiral Heihachiro Togo

JAPANESE ADMIRAL HEIHACHIRO TOGO, 1911. Relations between Japan and the United States were mostly friendly in the early 20th century, and Japan was a major trading partner. Admiral Togo won worldwide acclaim for utterly destroying the Russian fleet at the battle of Tsushima during the Russo-Japanese War. During the battle May 27–28, 1905, Togo sank 21 Russian ships and captured six others. (Courtesy Dan Kerlee.)

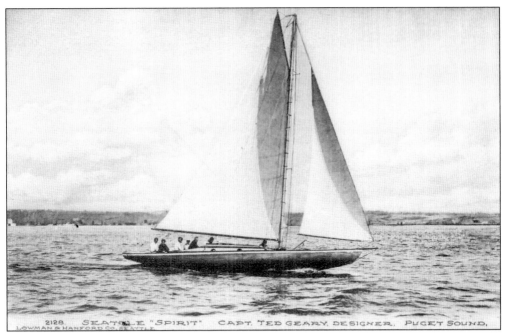

SEATTLE *SPIRIT,* 1910s. Ted Geary (1885–1960) was a famous naval architect who grew up in Seattle. He designed yachts, sailboats, fishing boats, tugboats, and freighters. Geary designed *Spirit* while still a sophomore at the University of Washington. In 1907, *Spirit* defeated the Canadian yacht *Alexandra* and won the Dunsmir cup. (Courtesy Dan Kerlee.)

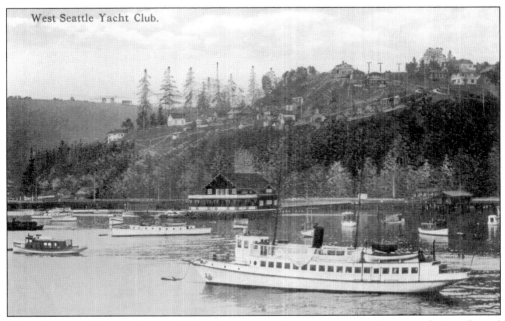

WEST SEATTLE YACHT CLUB, 1910s. Recreational boating was popular in early Seattle and by the late 1880s, the Seattle Yacht Club, which had its origins in West Seattle, was thriving. Following the opening of the Lake Washington Ship Canal in 1917, the club moved to Montlake on Portage Bay at the east end of Lake Union. (Courtesy author's collection.)

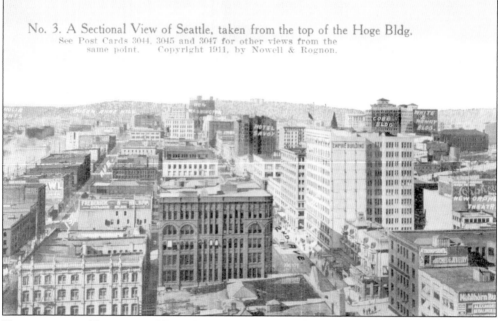

VIEW FROM THE TOP OF THE HOGE BUILDING, 1911. In this view looking north, the publisher has recorded many of the landmarks. The beautiful, steel-framed, Beaux-arts style Hoge Building was completed in 1911, and was named for financier John Hoge. It is considered Seattle's second skyscraper, after the Alaska Building. (Courtesy author's collection.)

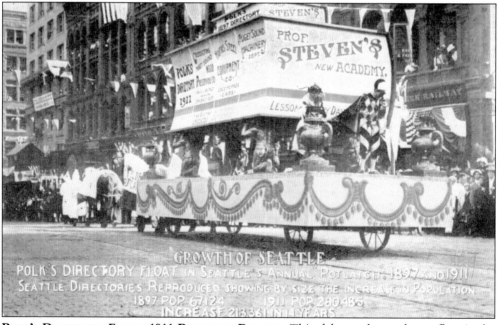

POLK'S DIRECTORY FLOAT, 1911 POTLATCH PARADE. This elaborate horse-drawn float in the 1911 Potlatch parade uses a small 1897 model of a Polk's Directory sitting atop a huge model of the 1911 Polk's Directory to graphically illustrate the population growth of Seattle during the previous 14 years. (Courtesy Dan Kerlee.)

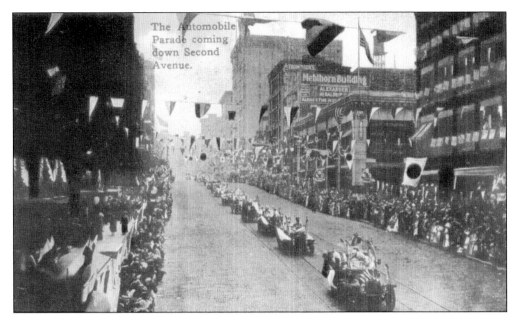

PARADE OF AUTOMOBILES, 1912. The city was just beginning to make the transition from horse-drawn carriages to automobiles in 1912. The annual Golden Potlatch celebration included this Automobile Parade on Second Avenue as part of the much larger parade. The parade included a surprisingly diverse assortment of floats, ethnic groups, community groups, and commercial promotions. (Courtesy author's collection.)

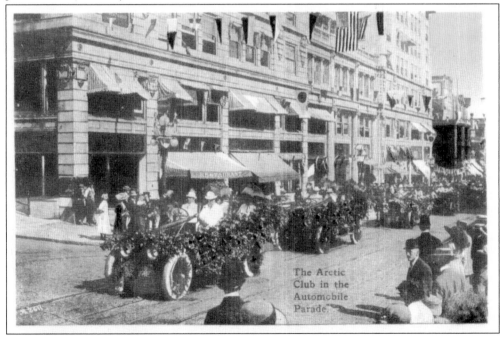

ARCTIC CLUB IN PARADE, 1912. The Arctic Club was founded in 1908 when the Alaska Club and an earlier version of the Arctic Club merged. The influential club combined socializing with promoting Alaska business interests, and was active in civic affairs. This image shows members participating in the 1912 Golden Potlatch parade. (Courtesy author's collection.)

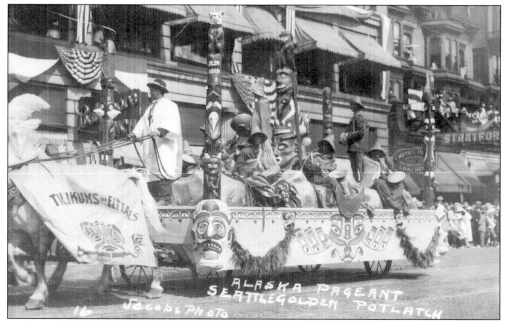

Tilikums of Elttaes at 1912 Potlatch Parade. The Tilikums were an extremely influential secret fraternal society in early Seattle. Its members were composed largely of the most prominent merchants, doctors, lawyers, politicians, and newspaper executives in the city. *Tilikum* is the Chinook word for "close friend." Elttaes is Seattle spelled backwards. (Courtesy Dan Kerlee.)

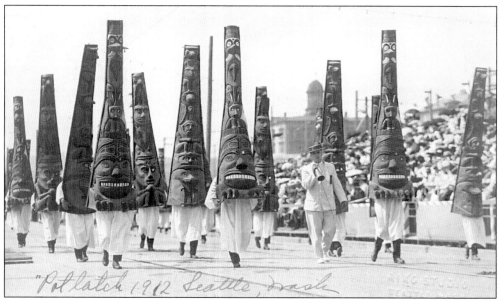

Tilikums of Elttaes at 1912 Potlatch Parade. The Tilikums were organized to act as friends of and promoters of Seattle. They spoke Chinook jargon and drew heavily upon Northwest Native American influences and images. Among the Tilikums' activities were putting together the Potlatch celebration and financing the statue of Chief Seattle at Tilikum Place. (Courtesy Dan Kerlee.)

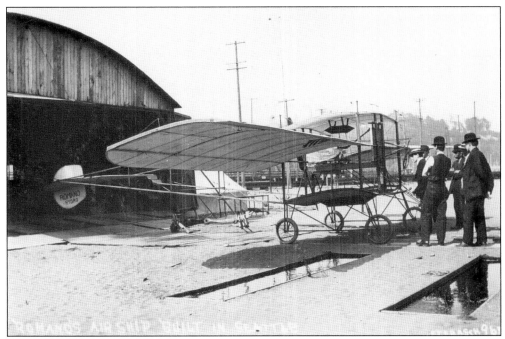

ROMANO'S AIRSHIP, 1912. Even before William Boeing's time, Seattle was on the cutting edge of aviation experimentation, as this rare image shows. Note the wing design of this aircraft. Almost all other early aircraft were biplanes. (Courtesy Dan Kerlee.)

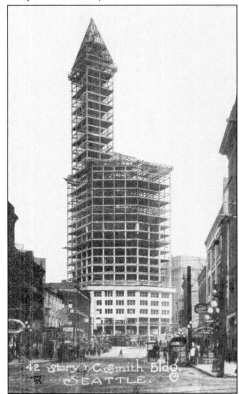

SMITH TOWER UNDER CONSTRUCTION, 1913. When the steel-framed Smith Tower was completed on July 4, 1914, it was the fourth tallest building in the world, and the tallest building west of the Mississippi River. The exterior of the first six floors is granite quarried from Index, Washington, and the entire lobby is finished in Mexican onyx. (Courtesy Robin Shannon.)

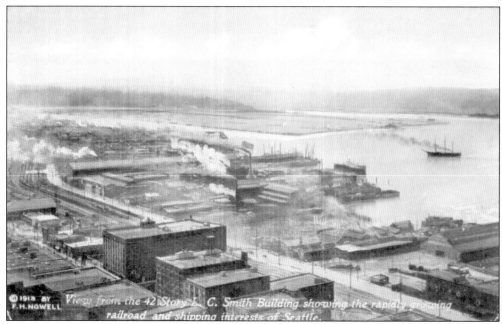

VIEW FROM THE SMITH TOWER, 1913. The perspective is to the southwest in this image made while the Smith Tower was still under construction. In the background the recently completed manmade Harbor Island sits largely vacant. (Courtesy author's collection.)

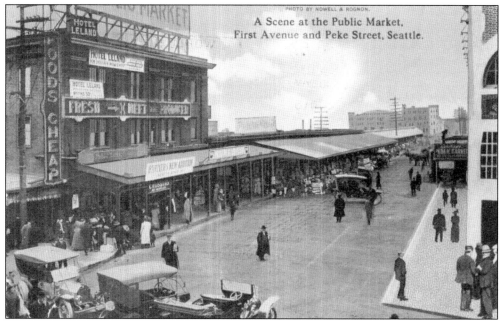

PIKE PLACE MARKET, 1913. The Pike Place Market was founded in 1907 to give local farmers a place to sell their products directly to the public. Local farmer's products were previously bought and resold by commission houses that allowed the farmers little control over the pricing of their goods. (Courtesy Robin Shannon.)

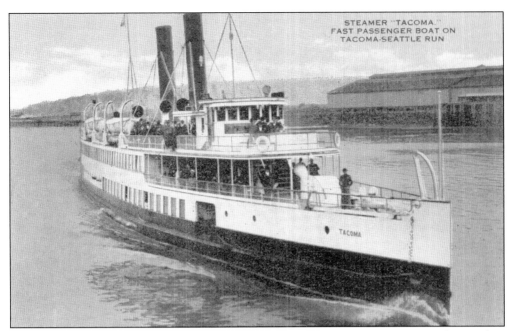

STEAMER *TACOMA*, 1913. The fastest steamer ever to travel on Puget Sound was the 214-foot double-stack *Tacoma*. It replaced the *Flyer* on the Seattle-Tacoma run in 1913, and broke the *Flyer*'s record with a time of one hour, seventeen minutes between the two cities. (Courtesy author's collection.)

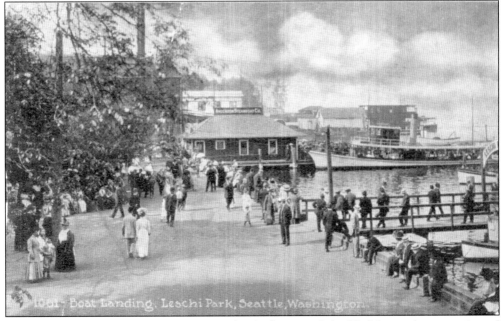

LAKE WASHINGTON BOAT DOCK, 1913. John Anderson, a Lake Washington boat captain and entrepreneur, established the Anderson Steamship Company and came to dominate the Lake Washington travel business with his own "Mosquito Fleet" of ships and ferries. His headquarters was at Leschi Park, seen here. (Courtesy author's collection.)

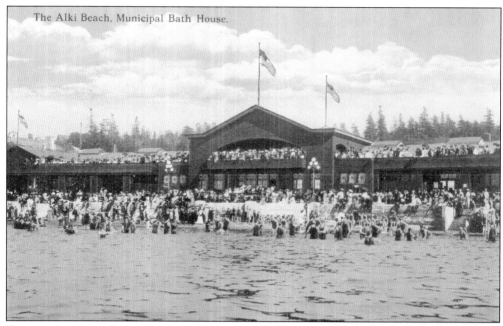

The Alki Beach, Municipal Bath House.

BATHERS AT ALKI BEACH, 1914. This popular beach was a favorite camp of pioneers and of Native Americans, according to the Seattle Parks Department. This section of beach became the first portion of the park in 1910. It was the first municipal saltwater beach on the West Coast. The bathhouse was built in 1911. (Courtesy author's collection.)

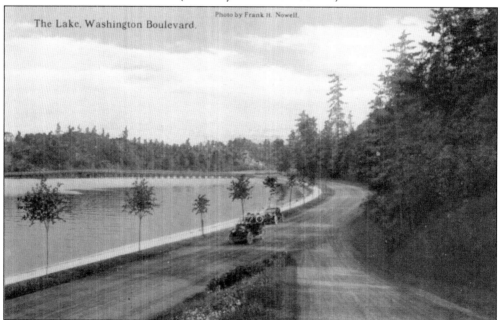

The Lake, Washington Boulevard.

Photo by Frank H. Nowell.

LAKE WASHINGTON BOULEVARD, 1914. During the 1900s, Seattle hired the famous Olmsted brothers to design a comprehensive system of parks and boulevards. The postcard folder from which this image was taken says, "Seattle Boulevards are unique in that they are constructed largely through wooded areas, serpentine fashion, connecting many of the parks and practically belting the city." (Courtesy author's collection.)

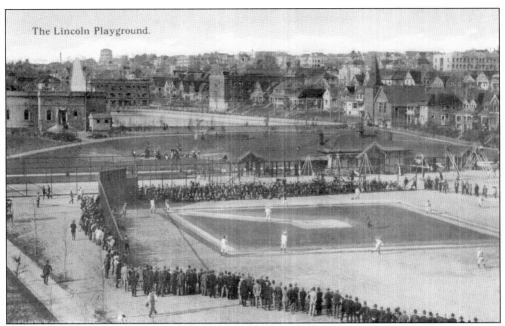

The Lincoln Playground.

BASEBALL GAME AT LINCOLN PLAYFIELD, 1914. By the early 1900s, baseball was a national pastime and the rage in Seattle. Lincoln Playfield was established in 1907 on Capitol Hill, just east of downtown, to service the affluent residents who wanted to live away from the commotion of downtown. (Courtesy author's collection.)

Japanese Pagoda Lantern in Mt. Baker Park.
A Gift from Kojiro Matsukatu of Kobe, Japan.

Photo by Webster & Stevens.

MOUNT BAKER PARK, 1914. The land on which Mount Baker Park sits was originally owned by Seattle pioneer David Denny. Donated to the city in 1898, it was included in the Olmsted's comprehensive plan for Seattle's parks. The stone pagoda was a gift from Kobe, Japan in 1911. (Courtesy author's collection.)

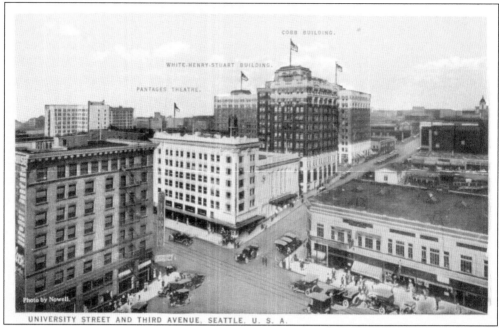

UNIVERSITY STREET AND THIRD AVENUE, SEATTLE. U. S. A.

UNIVERSITY STREET AND THIRD AVENUE, 1910s. The prominent buildings seen from Fourth Avenue eastward in this view are part of the "Metropolitan Tract." This 11-acre piece of land was the site of the University of Washington until the university relocated in 1895. Still owned by the university, the parcel is now one of the most valuable pieces of property in the city, and generates millions of dollars in revenues annually. (Courtesy author's collection.)

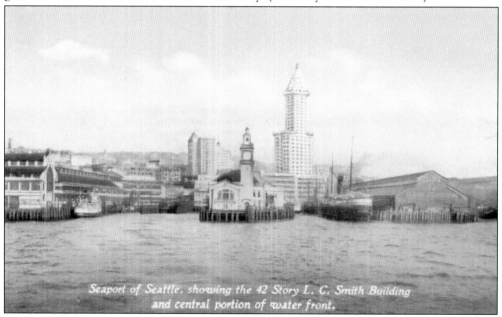

CENTRAL WATERFRONT, c. 1914. In the left foreground is the Grand Trunk Dock, in the center Colman Dock, and to the right the Alaska Steamship Company Dock. Behind them, the Alaska and Hoge Buildings rise at left center. The 42-story Smith Tower dominates the skyline at right center. (Courtesy author's collection.)

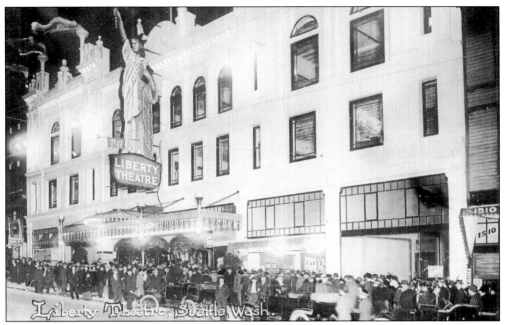

LIBERTY THEATER, 1910s. The Liberty Theater was located at 1520 First Avenue and known for its lavish and ornate interior. Note the flaming liberty torches on the roof of the building. (Courtesy Dan Kerlee.)

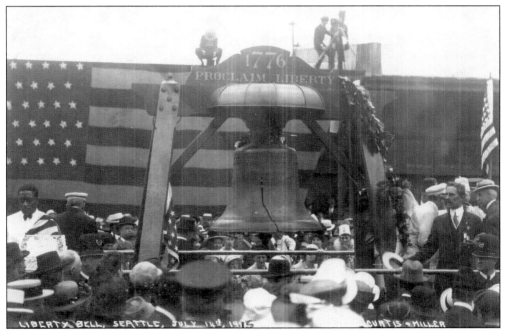

LIBERTY BELL VISITS SEATTLE, 1915. On July 14, 1915, the Liberty Bell visited Seattle, Everett, and Tacoma on a national tour, leading ultimately to the spectacular 1915 Panama-Pacific Exposition in San Francisco. Great throngs of joyful and enthusiastic people greeted the Liberty Bell locally and everywhere else the bell visited. (Courtesy author's collection.)

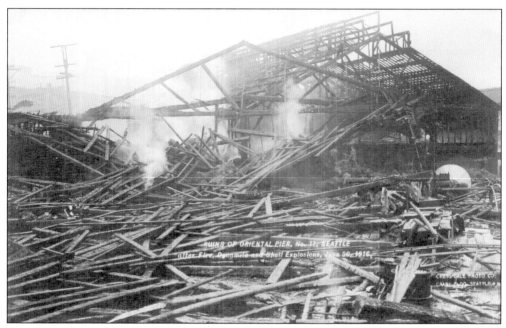

ORIENTAL PIER EXPLOSION, 1916. Seattle's docks experienced many tragic fires, explosions, and disasters over the years. Here are the still-smoldering ruins of the Oriental Pier. The caption reads, "Ruins of Oriental Pier, no. 11, Seattle after Fire, Dynamite and Shell explosions June 30, 1916." (Courtesy Dan Kerlee.)

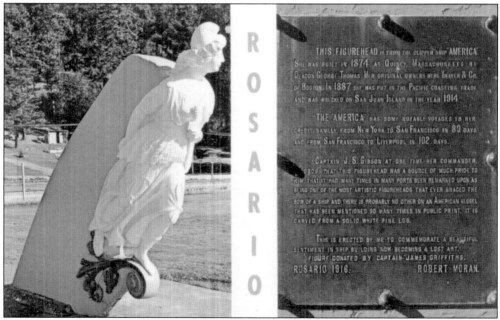

ROSARIO FIGUREHEAD, 1916. Ship builder Robert Moran built his luxurious family retreat on Orcas Island in 1909. In 1914, the famous clipper ship *America* was wrecked on nearby San Juan Island. Moran obtained its impressive figurehead from Capt. James Griffiths and installed it at his retreat in 1916. It survives today at Rosario Resort. (Courtesy author's collection.)

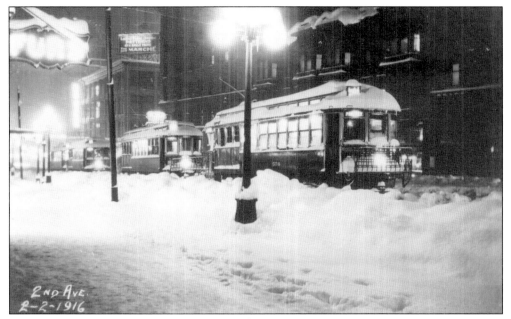

THE BIG SNOW, 1916. On January 31, 1916, after an unusually snowy month during which over 23 inches of snow had accumulated, it again began to snow relentlessly in western Washington. By February 2, an additional three feet had fallen in Seattle, including a record 21-plus inches in 24 hours. (Courtesy Kent Renshaw.)

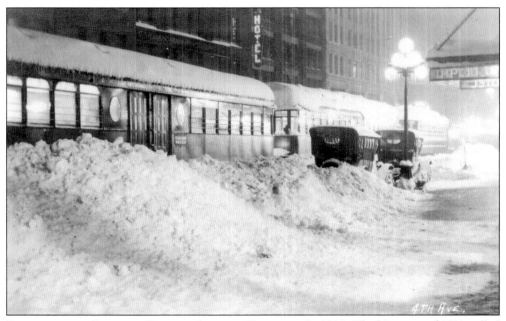

STREETCARS IN SNOW ON FOURTH AVENUE, FEBRUARY 2, 1916. The big snow of 1916 stalled Seattle's streetcars and hopelessly snarled traffic. Trains stopped, many public buildings closed, and roofs collapsed, including most famously, the spectacular collapse of the dome of St. James Cathedral. (Courtesy Kent Renshaw.)

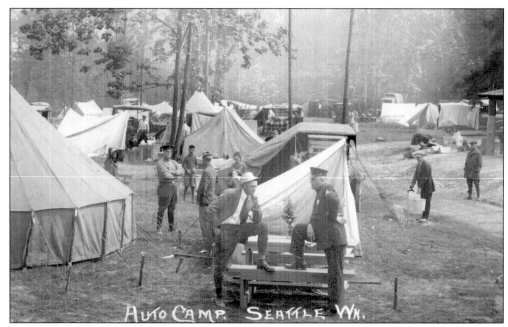

AUTO CAMP, 1910s. As the 1910s and 1920s progressed and American's love affair with the automobile developed, auto camps sprouted up around the country where travelers could camp next to their cars inexpensively. In this typical auto camp, there is a spigot with running water, picnic tables, and a picnic shelter. (Courtesy Dan Kerlee.)

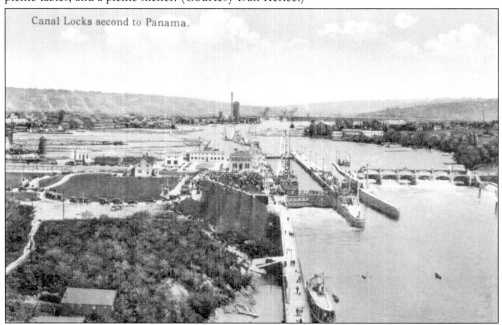

THE BALLARD LOCKS, C. 1917. The caption reads, "Canal Locks second only to Panama." The locks were opened to ship traffic in 1917, allowing ships to sail from Puget Sound into Lake Union and Lake Washington. The project had been the largest of its type up to that point, after the Panama Canal. The locks include fish ladders which allow fish to migrate upstream. (Courtesy author's collection.)

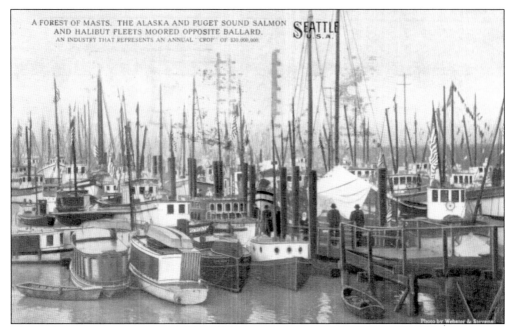

FISHERMEN'S TERMINAL, 1917. The downtown Seattle waterfront is not the city's only commercial waterfront. Fishermen's Terminal, located on the south shore of Salmon Bay opposite Ballard, is home to the North Pacific Fishing Fleet. This postcard is postmarked 1917, the same year the nearby Ballard locks opened accessing Salmon Bay. (Courtesy author's collection.)

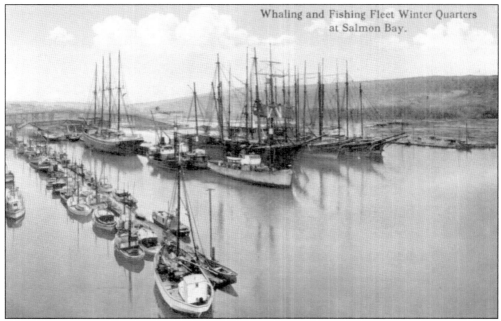

SALMON BAY, C. 1917. Here is another view of Seattle's other waterfront. Whaling ships operated out of Salmon Bay in the early 20th century in addition to fishing boats. The North Pacific Fishing Fleet still operates out of Salmon Bay today and is featured on the popular television show *Deadliest Catch*. (Courtesy author's collection.)

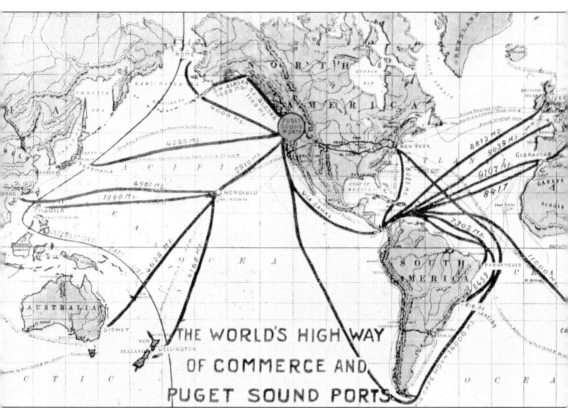

SEATTLE'S GLOBAL MARITIME COMMERCE, 1917. In 1882, the steamer *Madras* left Seattle bound for Honolulu and Hong Kong, marking the beginning of Seattle's trans–Pacific maritime commerce. The August 31, 1896, landing of the Japanese steamship *Miike Maru* at Schwabacher's Wharf in Seattle was greeted with great celebration, inaugurating the beginning of regularly scheduled trade between Seattle and the Far East. A contract between the Great Northern Railroad and Japan's Nippon Yusen Kaisha shipping line established Seattle as a principal point of entry for the company's trade, which quickly grew to enormous proportions. By 1914, according to Seattle's Museum of History and Industry, 75 percent of all imports from Asia to the United States passed through Seattle. This postcard is postmarked 1917 and shows the global extent of Seattle's trade. (Courtesy Dan Kerlee.)

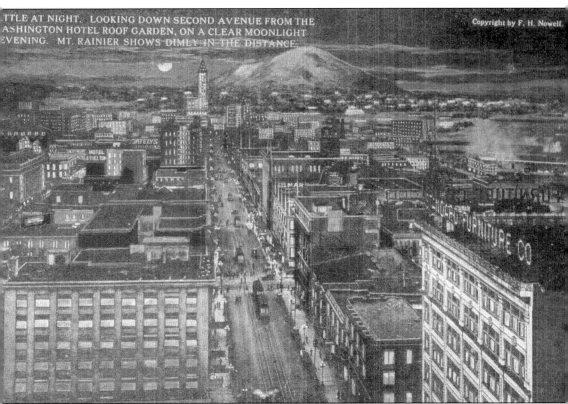

TTLE AT NIGHT. LOOKING DOWN SECOND AVENUE FROM THE ASHINGTON HOTEL ROOF GARDEN, ON A CLEAR MOONLIGHT EVENING. MT. RAINIER SHOWS DIMLY IN THE DISTANCE.

Copyright by F. H. Nowell.

NIGHT VIEW FROM THE ROOF OF THE WASHINGTON HOTEL, 1920. This dramatic moonlight view looks due south. The city is well illuminated. By 1920, Seattle claimed to be "the best lighted city in the world," with its progressive municipal power system run by Seattle City Light. The caption reads, "Seattle at night. Looking down Second Avenue from the Washington Hotel roof garden, on a clear moonlight evening. Mt. Rainier shows dimly in the distance." Among the signs faintly visible are the landmark Standard Furniture sign one half block down on the right, the Bon Marche sign two blocks down Second Avenue on the right, the Hotel Savoy sign halfway down Second Avenue on the left, and the Hotel Ethelton sign on the right side of Third Avenue. (Courtesy author's collection.)

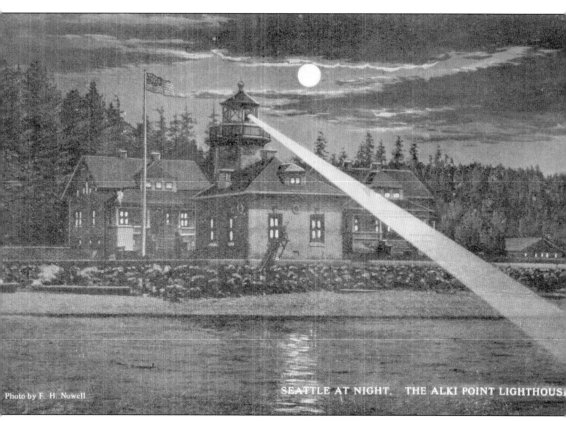

SEATTLE AT NIGHT. THE ALKI POINT LIGHTHOUSE

NIGHT VIEW OF ALKI POINT LIGHTHOUSE, 1920. The former site of the first settler's landing is now dominated by the Alki Point Lighthouse, one of 13 lighthouses around the shores of Puget Sound. This point of land is low-lying and potentially hazardous to ships. By the late 1850s, members of Hans Hanson's family were manning a kerosene or coal oil lamp to warn passing ships. In 1887, the United States Lighthouse Service assumed control of the site. The service called it Alki Point, using the name the original pioneers had called their settlement. The lighthouse was completed and electrified in 1913, replacing the old coal oil–burning lantern on a post. (Courtesy author's collection.)

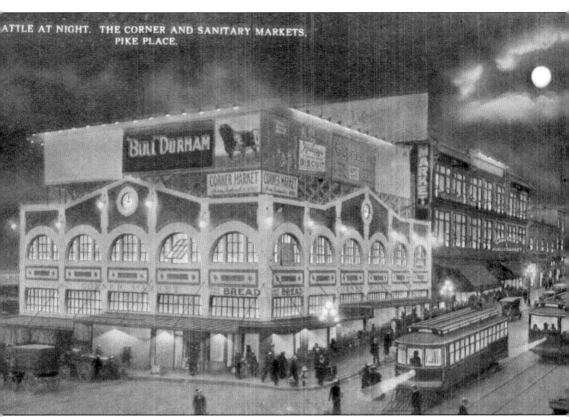

NIGHT VIEW OF PIKE PLACE MARKET, 1920. The hands of the clock on the building stand at 10:00 p.m. on this mostly cloudy night. The sidewalks are still busy, the buildings are well illuminated, and the streets and sidewalks are well lit. It is interesting to see that despite the proliferation of automobiles by 1920, horses and buggies were still delivering goods at the market. The perspective is looking northwest in this image. First Avenue is on the right. Today, the Pike Place Market's merchants still sell fresh produce, seafood, and other products directly to the consumer just as they did in the beginning. (Courtesy author's collection.)

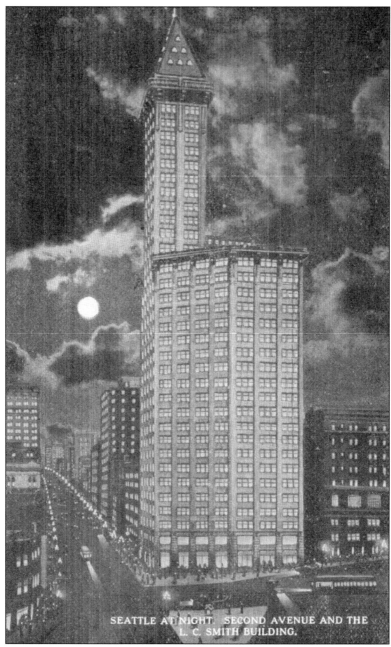

SEATTLE AT NIGHT. SECOND AVENUE AND THE
L. C. SMITH BUILDING.

Night View of the Smith Tower, 1920. The extent of the city's electrification is evident in this view of the Smith Tower. The building is illuminated from top to bottom. Second Avenue is illuminated by street lights as far as the eye can see. Seattle highlighted electricity in its advertising: "The Best Lighted City in America / Its streets are lighted by 17,407 lamps, making 1,050 miles of cluster and standard lighted streets / April 1905, one customer; April 1909, 7,500 customers; April 1920, 64,000 customers / Supplied current for the smallest homes and thousands of Electrical Horsepower for shipyards and other big industries / Has 4,282 miles of wire installed." These accomplishments were due in part to the foresight of former city engineer Reginald Thompson. (Courtesy author's collection.)

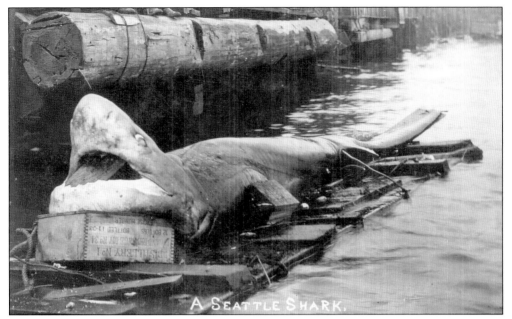

A Seattle Shark, Early 20th Century. Sharks are occasionally found in Puget Sound as this example shows. Note how the mouth is propped open with a chunk of log to display the large teeth. In 1886, a barracuda was caught in Elliott Bay. (Courtesy Dan Kerlee.)

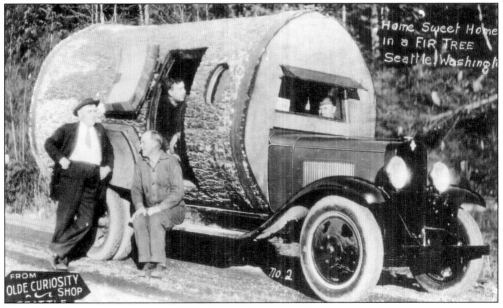

Log Recreational Vehicle, 1920s. In another example of the public's fascination with the Northwest's giant trees, this card published by Ye Olde Curiosity Shop shows a fully livable, one-log, Seattle recreational vehicle. (Courtesy Dan Kerlee.)

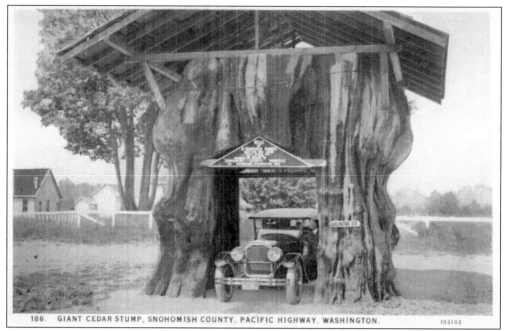

DRIVE-THROUGH STUMP, C. 1922. This western red cedar stump, 20 feet in diameter, was preserved by Snohomish County pioneers and located on the old Pacific Highway near Arlington, Washington. Located on the old Pacific Highway near Arlington, Washington, the stump was visited each year by thousands of motorists who drove through it. It is now found at the rest stop north of Smoky Point on north-bound Interstate Five. (Courtesy author's collection.)

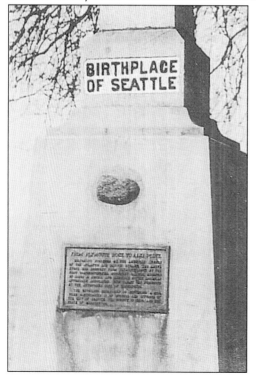

PLYMOUTH ROCK PIECE ON ALKI MONUMENT, 1926. This detail from an early black and white real photograph postcard shows Seattle's piece of Plymouth Rock, Massachusetts. The piece was brought to Seattle in 1926 by the first transcontinental auto caravan, and was intended to honor pioneers of both the Atlantic and Pacific Oceans. (Courtesy author's collection.)

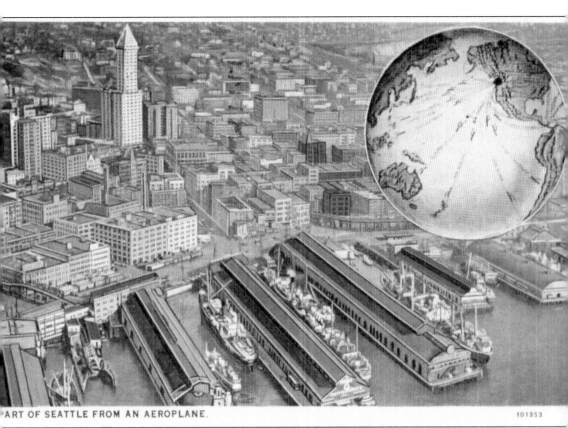

PART OF SEATTLE FROM AN AEROPLANE.

101353

SEATTLE'S GLOBAL MARITIME COMMERCE, 1928. The inset globe illustrates the extent of Seattle's trade. The handwritten message on the back says, "Been out here for the last ten days, taking in some of the most beautiful sceneries anyone ever wished to see and having a good time." During the 1920s, a particularly valuable trade item was silk, for which Seattle was the principal point of entry. Raw silk accounted for almost half the imports arriving in Seattle during this period. Cargo ships loaded with the costly merchandise would arrive from Japan and be loaded onto special high-speed silk trains to be rushed to the east coast for processing. The silk trains had sealed doors and armed guards, and set speed records as they hurried to their destinations. (Courtesy author's collection.)

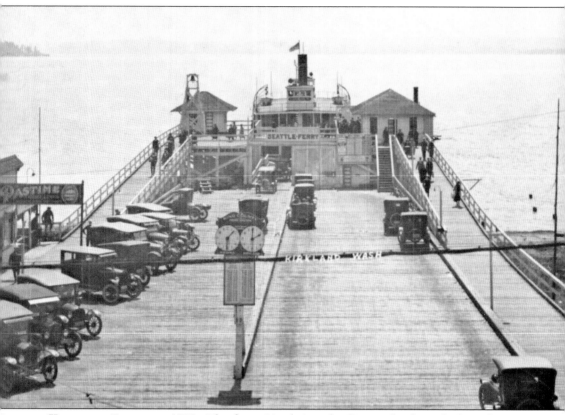

Kirkland Ferry, c. 1930. The ferry *Lincoln* is unloading at the ferry dock in downtown Kirkland in this view. The route ran from the end of Kirkland Avenue to Madison Street in Seattle from 1915 until 1950. The *Lincoln* was a beloved institution among eastside residents. It served Kirkland from 1915 until the Lake Washington floating bridge was completed in 1940, after which it was replaced on the run by the ferry *Leschi*. From 1915 until 1940, the *Lincoln* was the only ferry on the route. The *Lincoln* was also the largest ferry ever to travel on Lake Washington. The *Leschi* was the first ferry to carry cars on Lake Washington beginning in 1913, and the first automobile ferry in western Washington. The run was finally abandoned for good in 1950. Note the Pastime Restaurant sign advertising light lunches. (Courtesy author's collection.)

Five

DEPRESSION
AND WAR

The arrival of the Great Depression caught Seattle by surprise. After more than 30 years of almost uninterrupted growth and prosperity (except for a brief recession following World War I), many residents regarded Seattle as "the city that knew no hard times." When the stock market crashed in October 1929, many Seattle investors, like investors elsewhere, saw their assets vanish. Downtown construction ground to a halt in 1930 and no major new development occurred for almost 20 years. During 1933, panicking depositors, alarmed over the security of their savings, began withdrawing their money from banks. Many banks, unable to meet depositor's demands, folded. On March 3, 1933, the State of Washington declared a banking holiday and closed all banks. Two days later, the federal government declared a banking holiday until individual financial institutions could demonstrate financial solvency. Despite intervention by the city, state, and federal governments, unemployment continued to rise sharply in the early 1930s. A shantytown of unemployed workers sprang up south of downtown where sports stadiums now sit. Foreign trade withered, and the Port of Seattle cut back on operations.

During the last half of the 1930s, war clouds gathering on the horizon contained rays of hope for Seattle. Military-related trade soared. Thousands of workers commuted each day to the sprawling naval base across Puget Sound in Bremerton, and orders for Boeing aircraft increased.

The December 7, 1941, attack on Pearl Harbor was a mixed blessing for Seattle. On the one hand, many residents were certain that with its strategic west coast location and numerous military facilities the city would be a target. On the other hand, Depression-era unemployment faded away as young men were drafted and workers found jobs in shipbuilding, military aircraft construction, and war-related shipping. Boeing churned out 7,000 of its B-17 bombers during the war, which played a crucial role in Germany's defeat. It developed its enormous B-29 "Super Fortress," which dropped the atomic bombs on Hiroshima and Nagasaki that ended the war. Following Japan's surrender, Admiral Takata said, "American air power and the B-29 constituted the single greatest factor in Japan's defeat."

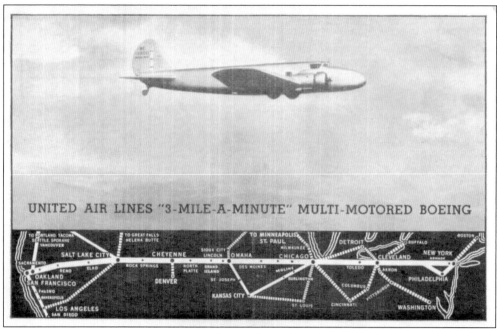

BOEING 247, 1933. The Boeing 247 first flew on February 8, 1933. The plane was highly innovative and ushered in a new era of commercial air travel. The 10-passenger plane could fly coast-to-coast in 20 hours including refueling stops, making it the fastest plane of its type at the time. (Courtesy Dan Kerlee.)

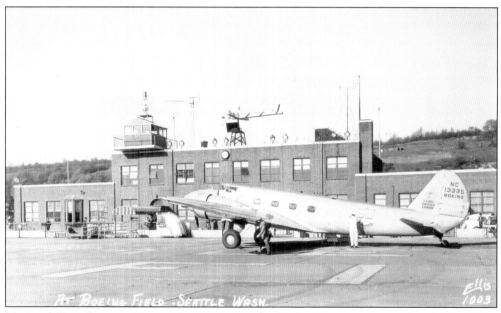

MODEL 247 AT BOEING FIELD, MID-1930s. By the Boeing Company's own description, "The revolutionary Boeing Model 247, developed in 1933, was an all-metal, twin-engine airplane and the first modern passenger airliner. It had a gyro panel for instrument flying, an autopilot, pneumatically operated deicing equipment, a variable-pitch propeller, and retractable landing gear." (Courtesy Dan Kerlee.)

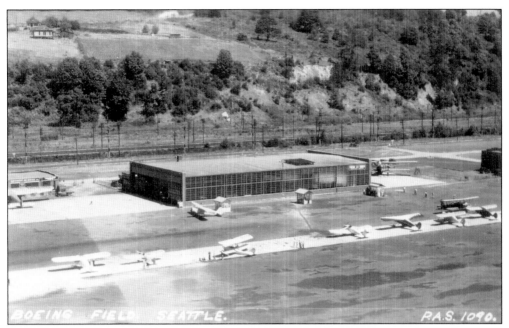

BOEING FIELD, EARLY 1930s. Boeing Field was officially dedicated on July 26, 1928. During the dedication ceremony, state representative W. W. Connor told 20,000 people, "Boeing Field today means more to Seattle and the Northwest than the building of the old Yesler Wharf meant to our pioneer citizens." (Courtesy Dan Kerlee.)

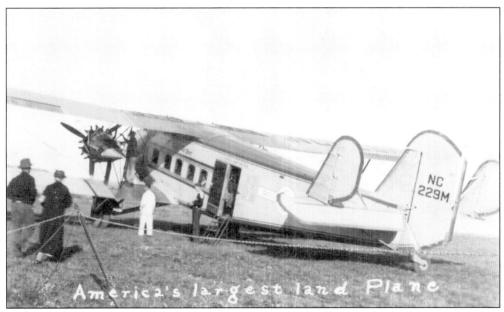

AMERICA'S LARGEST LAND PLANE, EARLY 1930s. The back of this card reads, "Boeing Passenger Plane. Captain W. M. Cary, Pilot. Bob Hoffman, Mechanic. Wing Spread, 90 ft. Length, 64 ft. Motors, 3 Pratt and Whitney. Top Speed, 150 M.P.H. Cruise, 125 M.P.H. Lands at 60 M.P.H. Capacity, 28 passenger." (Courtesy Dan Kerlee.)

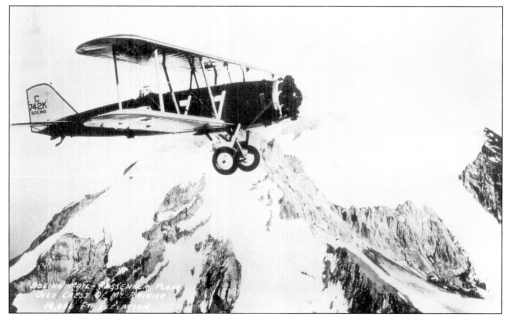

BOEING MODEL 40 OVER MOUNT RAINIER, EARLY 1930s. The first Model 40 was built in 1925 as a U.S. Post Office airplane to carry airmail. The improved Model 40A first flew on May 20, 1927. It was the first Boeing airplane built to include passengers. Handwritten on the back of this card is the following: "I flew to Sacramento in 1930 in one of these." (Courtesy Dan Kerlee.)

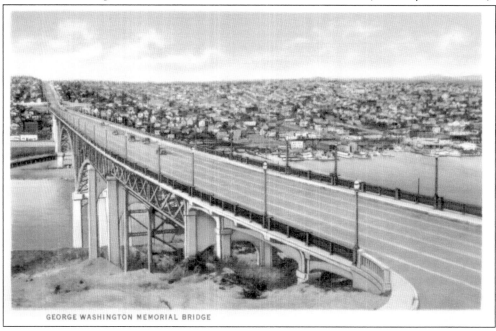

GEORGE WASHINGTON MEMORIAL BRIDGE, 1936. This historic bridge, also known as the Aurora Bridge, was dedicated on February 22, 1932, to commemorate the bicentennial of George Washington's birthday. It was the final link in U.S. Highway 99, which ran from Canada to Mexico. The bridge is now listed on both the state and national registers of historic places. (Courtesy author's collection.)

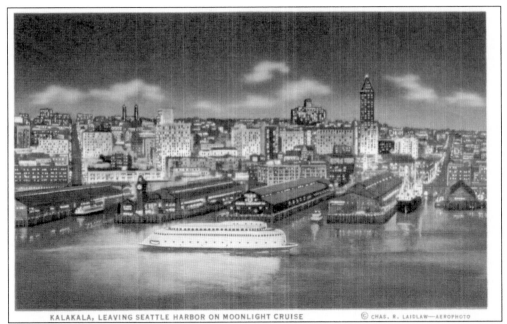

KALAKALA, LEAVING SEATTLE HARBOR ON MOONLIGHT CRUISE © CHAS. R. LAIDLAW—AEROPHOTO

MOONLIGHT ON THE FERRY *KALAKALA*, 1936. Not everything was a hardship during the Great Depression. In 1935, the world's first streamlined ferry, the silver-colored steel *Kalakala* (flying bird) went into service on Puget Sound. Besides transportation, it offered popular moonlight dance cruises before World War II. The Kalakala operated mostly on the Seattle to Bremerton run. (Courtesy author's collection.)

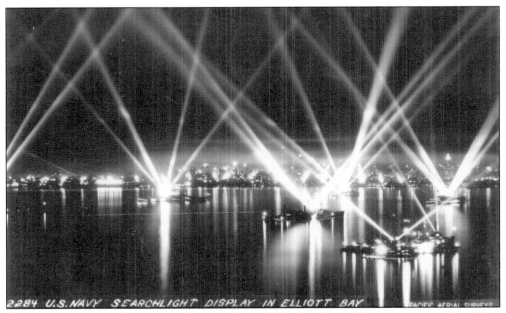

2284 U.S. NAVY SEARCHLIGHT DISPLAY IN ELLIOTT BAY PACIFIC AERIAL SURVEYS

NAVAL SEARCHLIGHT DISPLAY ON ELLIOTT BAY, 1939. The United States was not technically at war yet, but it was clearly in a state of readiness, as this dazzling display of U.S. Navy searchlights on Elliott Bay illustrates. The lights of the Seattle skyline shimmer in the background. (Courtesy Kent Renshaw.)

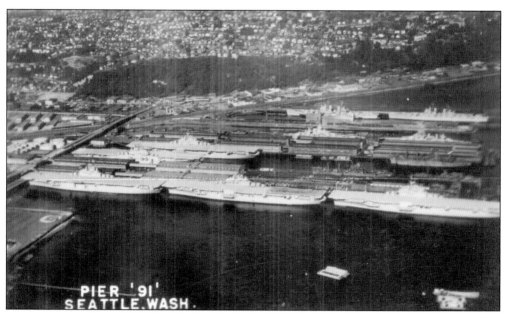

PIER 91, EARLY 1940s. Smith's Cove was the site of the former home of pioneer Henry Smith. Later, industries used the location and built piers. During the World War II and Korean War eras, the U.S. Navy operated out of the location. It was the port of embarkation for tens of thousands of soldiers heading for combat zones. (Courtesy author's collection.)

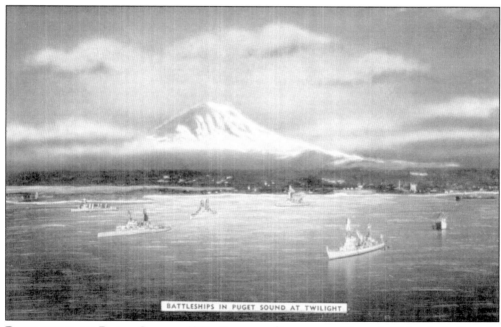

BATTLESHIPS ON PUGET SOUND, 1941. Because of its many military facilities, including the Puget Sound Naval Shipyard in Bremerton and the Boeing Company, the Seattle area was both a potential target and well-protected region during the Second World War. This 1941 scene shows battleships strewn across Puget Sound as Mount Rainier looms in the background. (Courtesy Robin Shannon.)

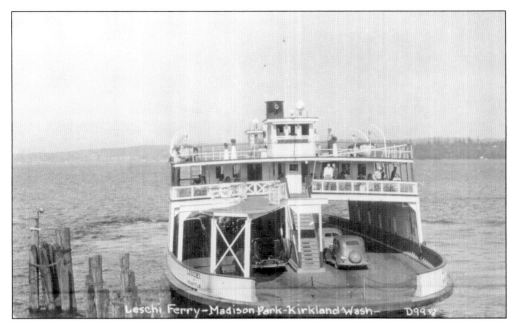

LESCHI FERRY ON LAKE WASHINGTON, 1940s. The ferry *Leschi* was the first automobile ferry in western Washington. Service was inaugurated in 1913 and operated until 1950, running from Madison Park to Kirkland. The opening of the Lake Washington Floating Bridge in 1940 spelled the ferry's demise. (Courtesy Dan Kerlee.)

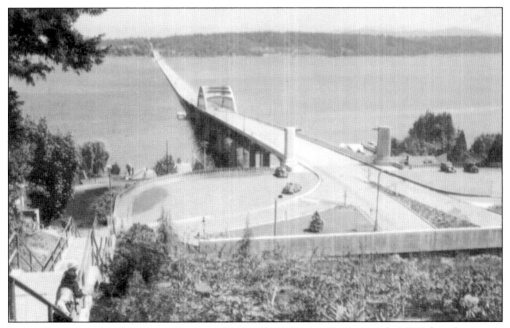

LAKE WASHINGTON FLOATING BRIDGE, 1940. The ingeniously designed, 3,387 foot-long span was the world's first floating concrete bridge. Its opening on July 2, 1940, made the colorful and beloved ferries that had served the lake for decades obsolete, but sped the development of the communities east of Seattle. (Courtesy author's collection.)

WESTERN PORTAL TUNNEL, LAKE WASHINGTON FLOATING BRIDGE, 1940. The artwork around the tunnel opening was designed by sculptor James Wehn, the same artist who created the Chief Seattle statue at Tillikum Place, as well as the famous Chief Seattle busts. The center reads, "City of Seattle—Portal of the North Pacific." (Courtesy author's collection.)

VICTORY SQUARE, MID-1940s. Victory Square was established in 1942 through the efforts of concerned citizens as a central location for home front activities during the Second World War. Located on University Street between Fourth and Fifth Avenues in front of the Olympic Hotel, Victory Square hosted concerts, rallies, and bond drives. (Courtesy Dan Kerlee.)

Six

Postwar Prosperity

The end of World War II on August 15, 1945, created a tremendous economic transition for Seattle and the nation. The city managed to escape some of the dislocation that followed the end of World War I. Wartime orders for ships and aircraft evaporated but home construction soared as soldiers returned home and resumed private lives. A baby boom ensued as they settled down, married, and began raising families. The suburban areas to the north, east, and south of Seattle mushroomed and many large, tract-style neighborhoods were built to accommodate the demand for housing. Colleges and universities boomed also as they were flooded by thousands of returning veterans taking advantage of the GI Bill benefit that promised a free college education to returning servicemen.

A new era in travel was born when Seattle-Tacoma International Airport was opened in 1948. The Northgate Shopping Mall, one of the world's first, was opened in 1950. In keeping with Seattle's Native American heritage, a large totem pole marked its main entrance. To mark its centennial in 1951 the city held its first Sea-Fair celebration, resuming its tradition of having a summer community festival.

Prohibition had ended in 1933, but it wasn't until 1949 that Washington's liquor laws were amended to allow the serving of liquor by the drink. This ushered in a new era for the hospitality industry as restaurants and cocktail lounges took advantage of the new regulation. Canlis Restaurant on the south end of the Aurora Bridge was one of the first to begin serving mixed drinks.

In 1948, television was introduced and KRSC (later KING) was Seattle's first television station. Thousands of Seattle residents flocked to the display window at Fredrick and Nelson during the 1948 holiday season to witness the new technological marvel.

In 1962, Seattle held its second world's fair, the Century 21 Exposition. On April 21, 1962, President Kennedy opened the exposition by pressing the same golden key that President Taft had used to open the Alaska-Yukon-Pacific Exposition.

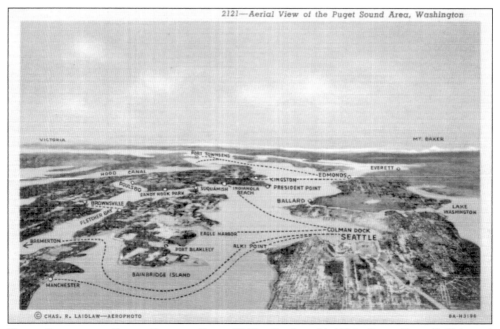

PUGET SOUND AND FERRY ROUTES, LATE 1940s. By the mid-1930s, Puget Sound's "Mosquito Fleet" of private ferries had consolidated into one private company, the Puget Sound Navigation Company, or Black Ball Line, which provided all ferry service for the region. In 1951, the state bought out the Black Ball Line and assumed responsibility for Puget Sound ferry service. (Courtesy author's collection.)

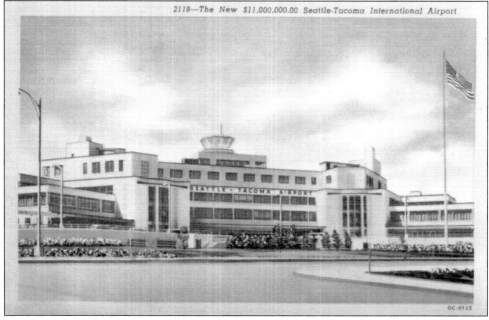

SEATTLE-TACOMA INTERNATIONAL AIRPORT, 1948. The Port of Seattle branched out from its maritime past when it completed construction of "Sea-Tac" in 1948. In keeping with Seattle's heritage, Sea-Tac originally advertised service to "the United States, Alaska, Hawaii, and the Orient." (Courtesy author's collection.)

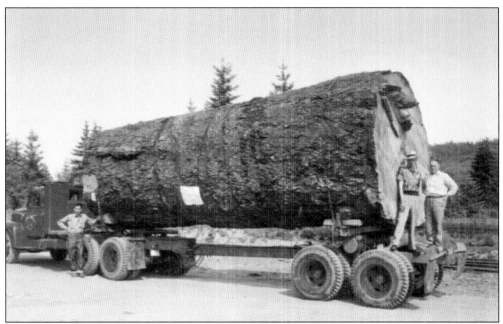

GIANT FIR LOG, EARLY 1950s. Lumber was Seattle's first industry, and 100 years later it was still one of western Washington's leading industries. The caption on the back of this card says, "This 13,000 board feet specimen is typical of the giants still found in the virgin forests of Oregon and Washington." (Courtesy author's collection.)

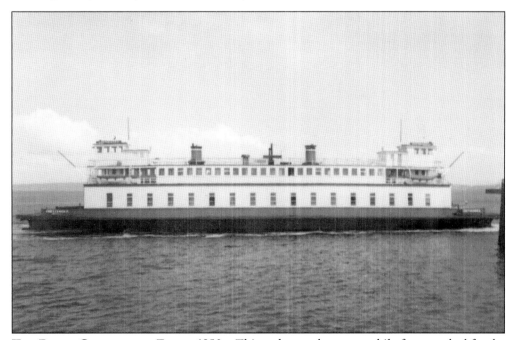

THE FERRY *CHETSAMOKA*, EARLY 1950s. This early wooden automobile ferry worked for the old Black Ball Line in the 1930s and 1940s, then for the State Ferry System following the state takeover in 1951. Chetsamoka was an Olympic Peninsula Indian chief in the Port Townsend area who was friendly toward early settlers. (Courtesy author's collection.)

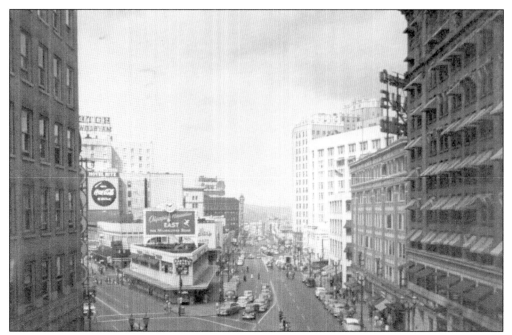

WESTLAKE, 1956. The area in this view is now occupied by Westlake Center. The center includes a four-story, 120,000-square foot shopping mall, a 21-story, 340,000-square foot office tower, the eastern terminus of the Seattle Center monorail, and one-acre Westlake Park. (Courtesy Robin Shannon.)

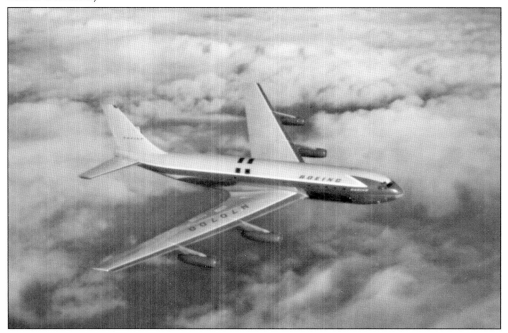

BOEING 707, 1958. Boeing entered the commercial jet airliner business with its model 707, and the aircraft was a huge success for the company. Soon airlines all over the world were delivering passengers in record numbers and in record times. Pres. John F. Kennedy chose the 707 to be the first Air Force One. (Courtesy Dan Kerlee.)

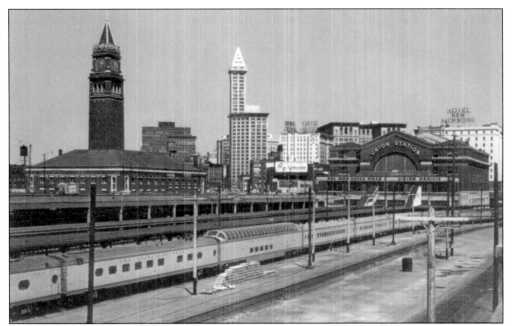

SEATTLE RAILROAD YARDS, 1950s. By 1909, four transcontinental railroads served Seattle: the Great Northern, The Northern Pacific, The Union Pacific, and the Chicago, Milwaukee, St. Paul, and Pacific (the Milwaukee Road). In this image, King Street Station is on the left and Union Station is on the right. (Courtesy author's collection.)

THE GREAT NORTHERN RAILROAD, 1950s. The Great Northern Railroad, with its famous mountain goat logo, was the first transcontinental railroad to begin serving Seattle beginning in 1893. Here a Great Northern passenger train rolls eastward alongside the Skykomish River and through the Cascade Mountains northeast of Seattle. (Courtesy author's collection.)

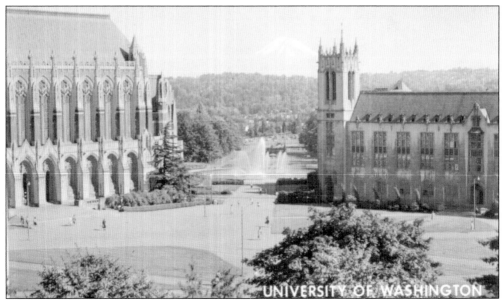

UNIVERSITY OF WASHINGTON LOOKING SOUTH, EARLY 1960s. Compare this view with the similar view of the AYPE on page 68. Suzzalo Library is on the left, and the administration building is on the right. Drumheller fountain in the center was originally built for the AYPE. (Courtesy author's collection.)

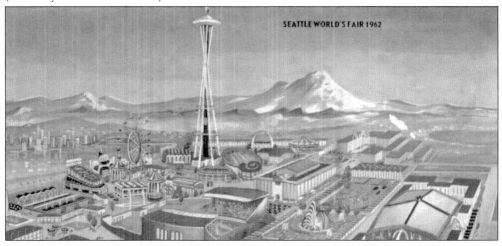

CENTURY 21 EXPOSITION, 1962. In 1909, 14-year-old Al Rochester frequently visited the Alaska-Yukon-Pacific Exposition. The experience made a lifelong impression on him. In 1955, Rochester, now a Seattle city councilman, conceived the idea of having a second world's fair to commemorate the 50th anniversary of the AYPE. He discussed the idea with business associates and it was well received. A committee was formed to win support for the fair and begin planning. It was eventually decided that 1959, the anniversary of the AYPE, was too soon and didn't allow enough time for planning. The year 1962 was agreed upon. The 1957 launch of the Russian satellite *Sputnik* made space and science a hot topic in the United States, and the themes of science, space, and the future were made the focus of the now-entitled Century 21 Exposition. The fair portrayed an optimistic, technologically oriented view of the future and was very successful, with 10 million attendees in its six month run and an operating profit. The Space Needle and the Seattle Center are lasting legacies of the exposition. (Courtesy Dan Kerlee.)

Seven

SEATTLE AND A BRIEF HISTORY OF POSTCARDS

Interestingly, the rapid growth of Seattle during the Gold Rush era parallels the rapid growth of postcards. A few cards, mostly advertising cards, were distributed prior to 1893, but their use was not widespread. Both government-issued cards and privately published cards were produced for the 1893 Columbian Exposition in Chicago, and these achieved a certain level of popularity. Postal regulations, however, limited the development of privately published cards and only the government was allowed to use the word "postcard" or post card. On May 19, 1898, Congress granted private publishers the right to print and sell cards that bore the inscription "Private Mailing Card" or "Souvenir Card" on the back. Also in 1898, the postage for mailing a privately issued card was reduced from 2¢ to 1¢. In 1901, further Congressional legislation allowed private companies to use the word "postcard." These improvements ultimately made postcards enormously popular. The publishing of postcards doubled every six months. All postcards still had undivided-backs and only the name and address of the recipient could be written on the back. Any message had to be written on the front of the card. Postcards with the familiar divided back were finally allowed in 1907, and postcards entered a golden age of unprecedented popularity, with hundreds of millions mailed annually in the United States. Also, beginning around 1900, real black and white photograph postcards were introduced. Around 1906, Kodak pioneered a camera that allowed users to take a photograph and print it directly onto postcard paper. There was even an opening in the back of the camera that allowed the photographer to write a caption with the attached metal scribe. These advancements made real photograph postcards extremely popular beginning during this period. As a result of these innovations, this period in Seattle's history is well documented on postcards.

During the World War I era (1914–1918), the importation of high quality postcards from Germany stopped. The white-bordered postcard, which used less ink, evolved as a cost-saving measure. Around 1930, the "linen" postcard was introduced, so-called because the high rag content of the paper gave it a linen-like appearance. Finally, around 1939 the "photochrome," or real color photograph postcard, was launched. By the 1950s, color photograph postcards dominated the market.

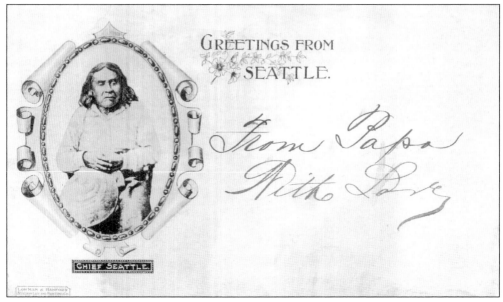

CHIEF SEATTLE PRIVATE MAILING CARD, 1898–1901. This early postcard featuring the famous photograph of Chief Seattle illustrates how the sender had to write on the front of the card on private mailing cards. In this case, the publisher has left ample room for a message. (Courtesy author's collection.)

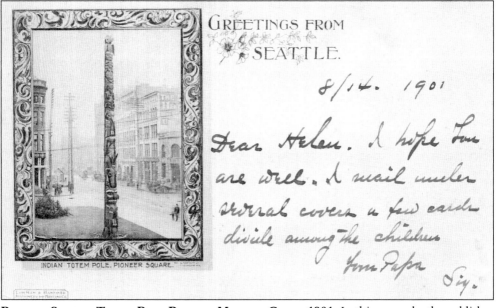

PIONEER SQUARE TOTEM POLE PRIVATE MAILING CARD, 1901. In this example, the publisher has again left ample room on the front of the card for a message. This card was issued less than two years after Seattle acquired the Pioneer Square Totem Pole. (Courtesy author's collection.)

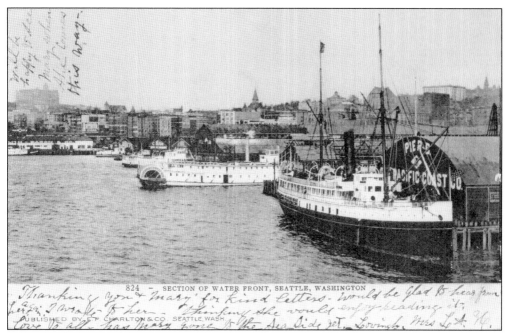

SEATTLE CENTRAL WATERFRONT UNDIVIDED-BACK POSTCARD, 1906. This undivided-back postcard illustrates how senders had to utilize the limited space on the front of postcards for messages in the undivided-back era. Such messages often contain valuable historical information. Note the side-wheeler behind the steamer in the foreground. (Courtesy author's collection.)

UNDIVIDED-BACK POSTCARD REVERSE, 1906. This example shows how only the name and address of the recipient was allowed on the back side of an undivided-back postcard. Note the instructions saying, "This side is exclusively for the address." (Courtesy author's collection.)

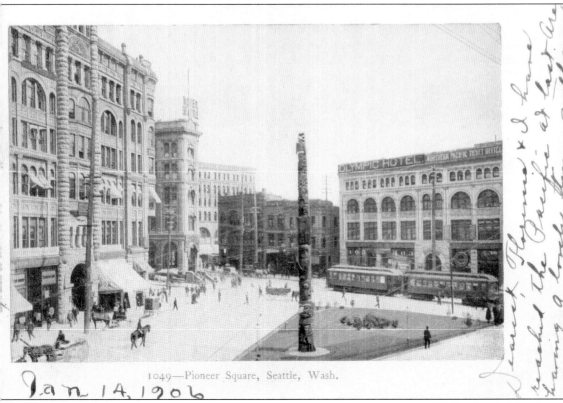

1049—Pioneer Square, Seattle, Wash.

Jan 14, 1906

Dearest, Florence & I have reached the Pacific at last. Are having a lovely time & ill...

PIONEER SQUARE UNDIVIDED-BACK POSTCARD, 1906. Many publishers of undivided-back postcards left very little room on the front of the card for writing a message, as seen here. In the image, the building on the left is the Pioneer Building, built after the Great Seattle Fire by Henry Yesler. Pioneer Square is the heart of Seattle. It is where Yesler's Mill and Yesler's Wharf were located. Where the Pioneer Square pergola now stands, water used to lap onto the shore. Everything currently to the west is built on fill. Early Seattle was built on a peninsula connceted to where Pioneer Square now exists by a narrow bottleneck of land. The early homes and businesses were centered around First Avenue South, then called Front Street. Most of the area is now incorporated into the Pioneer Square Historical District. (Courtesy author's collection.)

DIVIDED BACK POSTCARD REVERSE, 1908. This is an example of an early divided back postcard. The publisher has left careful instructions denoting a space for each part of the postcard. The left side says, "This space for writing." The upper right says, "This space reserved for postmark." The lower right says, "This space for address only." (Courtesy author's collection.)

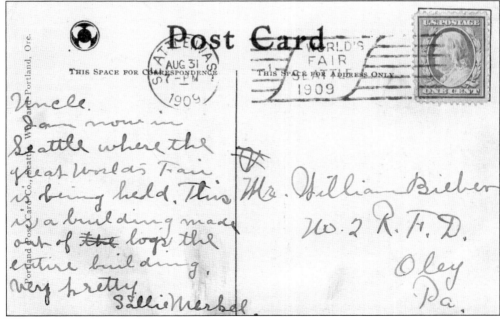

DIVIDED BACK POSTCARD REVERSE, 1909. This is another example of an early divided back postcard. The publisher has designated "This space for correspondence" on the left side, and "This space for address only" on the right side. Note the Seattle World's Fair cancellation and the handwritten message about the world's fair. (Courtesy author's collection.)

Mt. Rainier by Moonlight from Lake Washington © CHAS. R. LAIDLAW - AEROPHOTO

LINEN TYPE POSTCARD, 1936. The linen-like texture of this style of postcard is faintly visible in this image. This type of postcard also lent itself well to inks with vivid colors and many linen postcards are brilliantly colorful. Mount Rainier is a perennially favorite subject for Seattle area postcards. (Courtesy author's collection.)

SUNSET ON PUGET SOUND, 1910. This beautiful divided-back postcard was postmarked in Burlington, Washington. The caption on the reverse is a statement by Theodore Roosevelt, who said, "One never gets the same impression twice of Puget Sound scenery. It affords a constantly changing panorama of sea, sky, and mountains." (Courtesy author's collection.)

Discover Thousands of Local History Books
Featuring Millions of Vintage Images

Arcadia Publishing, the leading local history publisher in the United States, is committed to making history accessible and meaningful through publishing books that celebrate and preserve the heritage of America's people and places.

Find more books like this at
www.arcadiapublishing.com

Search for your hometown history, your old stomping grounds, and even your favorite sports team.

Consistent with our mission to preserve history on a local level, this book was printed in South Carolina on American-made paper and manufactured entirely in the United States. Products carrying the accredited Forest Stewardship Council (FSC) label are printed on 100 percent FSC-certified paper.

MADE IN THE USA